The Transported Man

EDITED BY MARC-OLIVIER WAHLER

ELI AND EDYTHE BROAD ART MUSEUM
AT MICHIGAN STATE UNIVERSITY

The Transported Man

MSU BROAD

Foreword

Marc-Olivier
Wahler

A table, an elephant, a bug zapper, a bar of soap, a mirror, a cat, a vending machine, and fireflies: these are some of the objects encountered in *The Transported Man*. They can be seen and understood as ordinary objects, but they gain new meaning when more information is revealed, and when new interpretations are made possible. The table floats in midair. The elephant performs an impossible trick. When the bug zapper kills a fly, the building's electricity shuts down. The soap is the liposuctioned fat of an Italian politician. The reverse side of the mirror is signed. The cat is ready for space travel. The vending machine beams its cans to its far-away twin. Fireflies and crickets flash and chirp in synchronicity.

In the novel *The Prestige*, Christopher Priest—who contributes a compelling essay to this publication—depicts a trick he calls "the Transported Man," which exemplifies the three phases of any magic trick: a magician appears onstage (the Pledge), disappears through a door (the Turn), and reappears immediately from another door located a few yards away (the Prestige). The impresario of a rival magician doesn't take long to figure it out: the transported man has a twin. But no one else buys it. Everyone knows there is a trick, but they want to believe in something else, something that is possible and impossible at the same time.

To be efficient, a magic trick, like many other illusions, relies on a system of belief cultivated between the magician and his/ her audience. The wider the gap between what the audience sees and what it is asked to believe, the more efficient and spectacular the trick is going to be. A good trick works only if the spectator can navigate between these two poles—between the feeling of witnessing pure magic and the impression of seeing an ordinary scene. If the spectator decides to consider only one of the poles (a simple fact or pure magic), the trick won't work. The belief he attributes to what he sees acts like a cursor in a field implemented not by category but by intensity.

Spectators wonder what happens in the ineffable moment when the magician disappears and reappears on the other side of the stage in the same way viewers might wonder what happens

when pigments on canvas disappear in front of their eyes and reappear—visually unchanged—as a painting, when a box of soup cans get transfigured into a sculpture, when an ordinary object becomes invisible and reappears as an artwork. How can an old magic trick like the Transported Man help us understand the way an object can be "transported" between various states of being while gaining the power of embodying multiple identities? Or as Francis Ponge states in a poem reproduced in this book, how do we learn to "take the side of things," to see a single pebble as embodying several things on several levels at once?

This question is central to this book. It carries on an inquiry that started years ago, as explained further in the published conversation between the art historian and philosopher Christophe Kihm and me. It reflects on hints left in an exhibition where a bar of soap triggered a diplomatic uproar, where the museum director got swallowed by an alligator during the press preview, where bottles randomly exploded into dust particles, where dogs were enthralled by Eric Satie music, and where Red Army soldiers laughed in front of absent paintings.

I can't resist the urge to end this foreword the same way an announcer would theatrically present a magician on stage, hence paraphrasing a famous quote from the movie *The Illusionist*: "Life and death. Space and time. Fate and chance. These are the forces of the universe. Tonight, ladies and gentlemen, I present to you a book that has unlocked these mysteries. From the farthest corners of the world, where the dark arts still hold sway, it returns to us to demonstrate how nature's laws may be bent. I give you *The Transported Man*."

We've forgotten why Joan
Fontaine leans over the edge of
the cliff and what Joel McCrea
was going to do in Holland.

We don't remember why
Montgomery Clift was
maintaining eternal silence or
why Janet Leigh stopped at
the Bates Motel or why Teresa
Wright still loves Uncle Charlie.

We've forgotten what Henry Fonda wasn't entirely guilty of and why exactly the American government had hired Ingrid Bergman.

But we remember a handbag.

But we remember a bus in the desert.

But we remember a glass
of milk, the sails of a windmill,
a hairbrush.

But we remember a row of
bottles, a pair of spectacles, a
sheet of music, a bunch of keys.

Because through them Alfred Hitchcock succeeded where Alexander, Julius Cesar, and Napoleon had all failed: by taking control of the universe.

—Jean-Luc Godard

Daniel Morgan, *Late Godard and the Possibilities of Cinema* (Los Angeles: University of California Press, 2013), 172–73

The Objects

THE FIREFLIES (WITH CRICKETS,
 PENDULUM, RECORDS,
 LP PLAYERS, COMPUTERS,
 AND GREEN PLANTS)
THE ELEPHANT
THE LIGHT SWITCH
THE TABLE
THE PLEXIGLAS AND ITS MEATS
THE CAT
THE MAN BENDING
THE MAN AND ITS RULER
THE ABACUS
THE SHOES
THE AIR DUCT (I)
THE SONG FOR THE DOGS
THE MAN DIGGING
THE MUSEUM VISIT
THE HAND (FLOATING I)
THE BRICKS
THE HANDS (MOVING)
THE CLOTH
THE THUNDER
THE BLACK MIRROR
THE SOAP
THE WOODEN PLANK
THE WINDOWS
THE MIRROR (SIGNED)
THE MEETINGS
THE ROCKS
THE CONCRETE BOOK
THE HANDS (RECEIVING)
THE WEEDS
THE BISHOP
THE MAGICIANS
THE AIR DUCT (II)

THE ALLIGATOR, THE JOURNALIST,
 AND THE DIRECTOR
THE VENDING MACHINE
THE HAND (FLOATING II)
THE PEDESTAL
THE CHAIR
THE EXPLODING BOTTLE
THE MIRROR (SHOE GAZER)
THE DRAIN
THE DOUBLE DOOR
THE LETTER
THE ELECTROMAGNETIC FIELD
THE FLY CATCHER
THE HOLE

19

Robin Meier and André Gwerder
Synchronicity (East Lansing), 2017

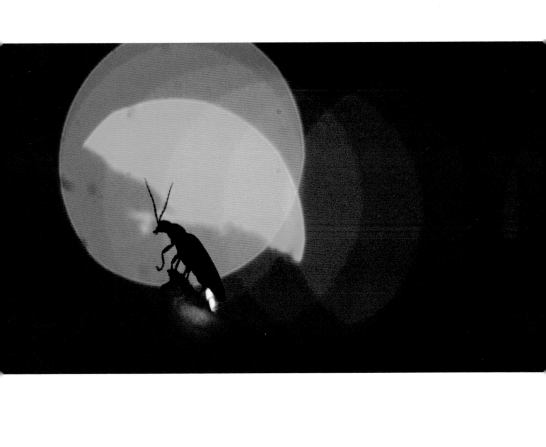

Daniel Firman
22 *Loxodonta,* 2017

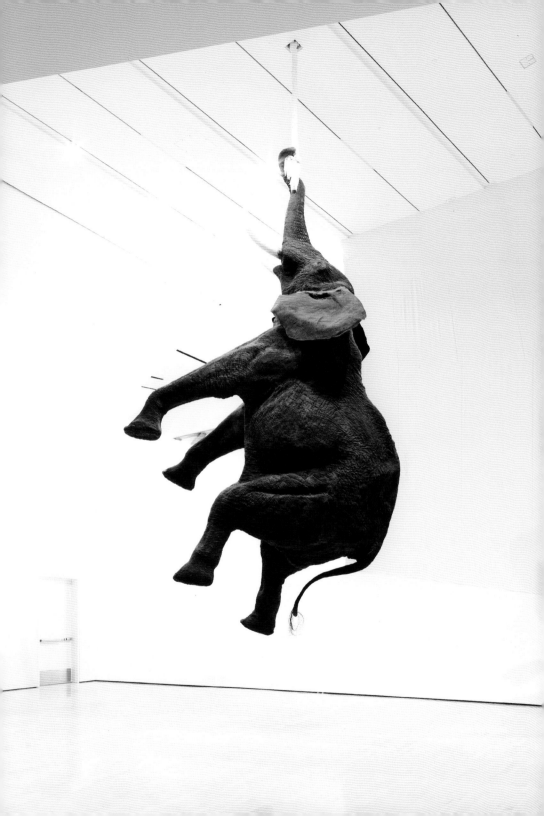

Ceal Floyer
Light Switch, 1992–1999

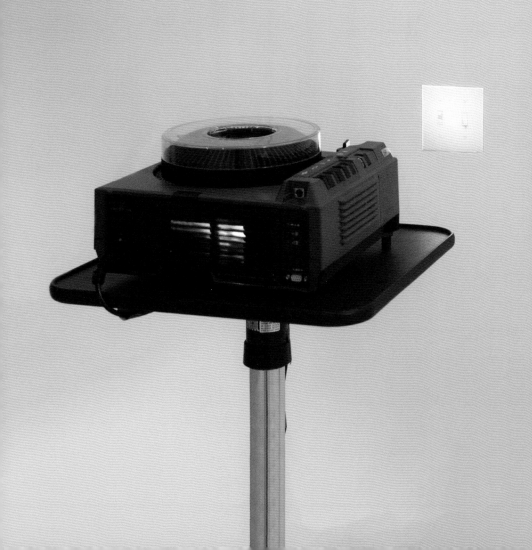

THE OBJECTS

Roman Signer
Table, 2009

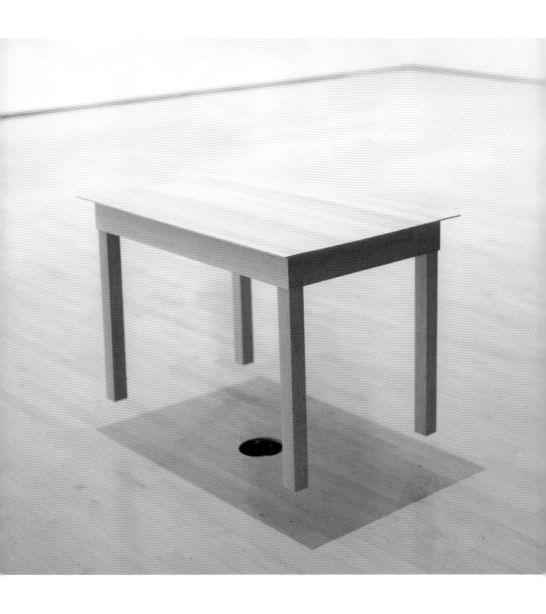

Paul Thek
Untitled (L-Column), 1965–1966

THE OBJECTS

Werner Reiterer
Beginnings of Space Travel, 2002

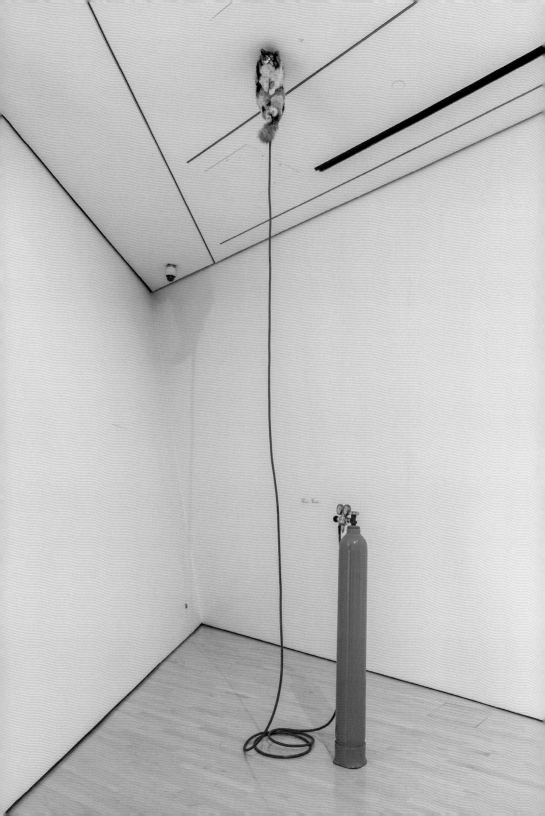

Sigurður Guðmundsson
Rendez-vous, 1976

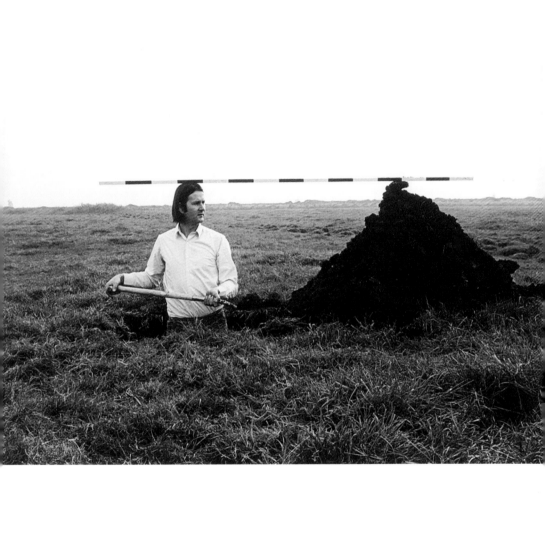

Sigurður Guðmundsson
Study for Horizon, 1975

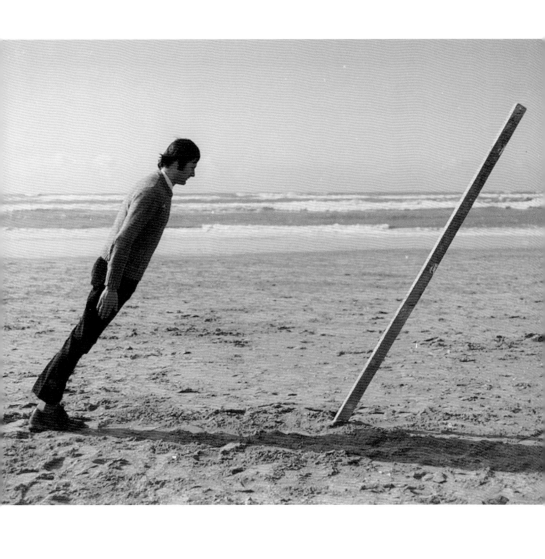

Alicja Kwade
Linienland II, 2017

THE OBJECTS

THE OBJECTS

38 Jason Dodge

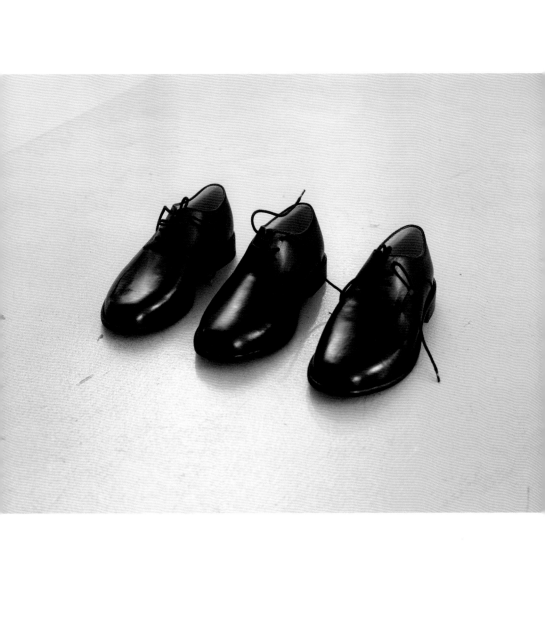

Charlotte Posenenske
Series D Vierkantrohre (Series D Square Tubes), 1967–2007

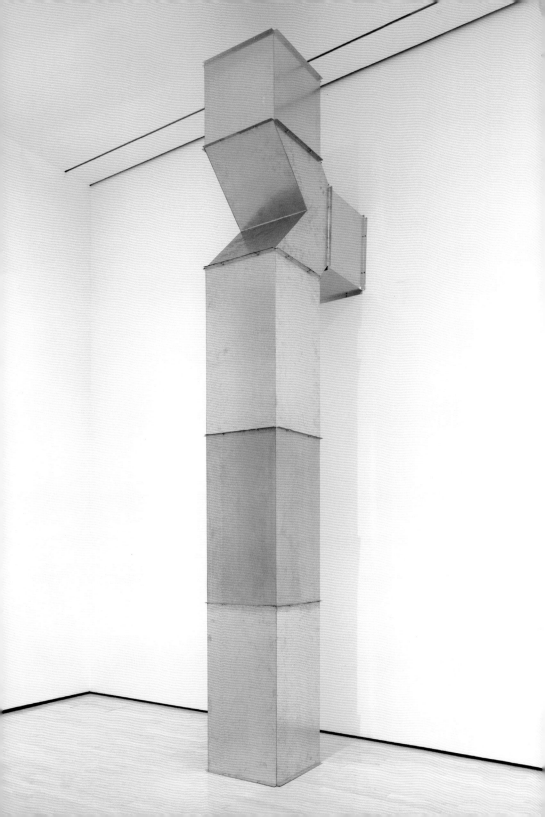

Dave Allen
For the Dogs. Satie's "Véritables Préludes Flasques (pour un chien),"
1912, rendered at tone frequencies above 18KHz, 2002

Keith Arnatt
Self Burial in nine stages, June '69, for Gustav Adolf and Stella Baum, 1969

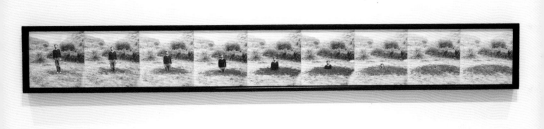

Melvin Moti
No Show, 2004

Comrades, look around and
feel the magic in this room.

THE OBJECTS

Urs Fischer
48 *Imaginary Pain*, 2007

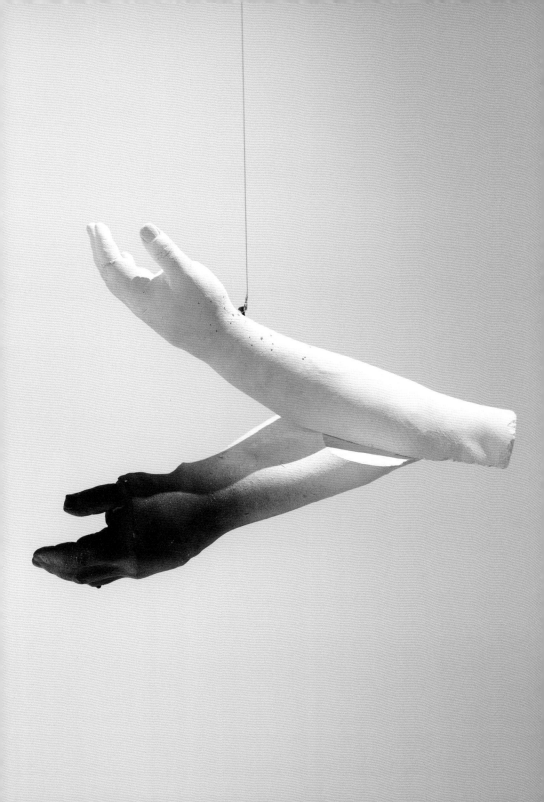

William Anastasi
What was real in the world, 1964

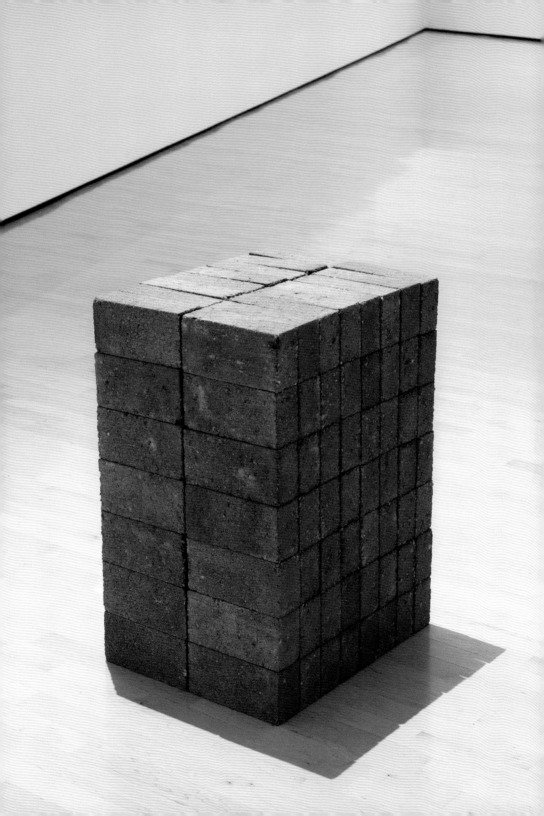

Anna Maria Maiolino
Ad Hoc, 1982

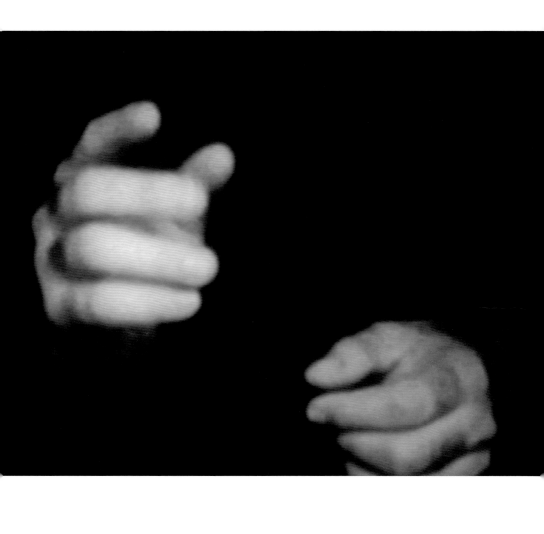

Robert Overby
Two Window Wall Map, 1972

THE OBJECTS

Hannah Rickards
56 *Thunder,* 2005

A recording of a single clap of thunder was stretched
in length from eight seconds to seven minutes. The resulting
sound was transcribed into a musical score for six
instruments. The musical score was performed, recorded
and then reduced in length to eight seconds.

A flute, trumpet, trombone, cello, viola and violin now
replicate the original thunder.

Joachim Koester
The Magic Mirror of John Dee, 2006

Gianni Motti
Mani Pulite (Clean Hands), 2005

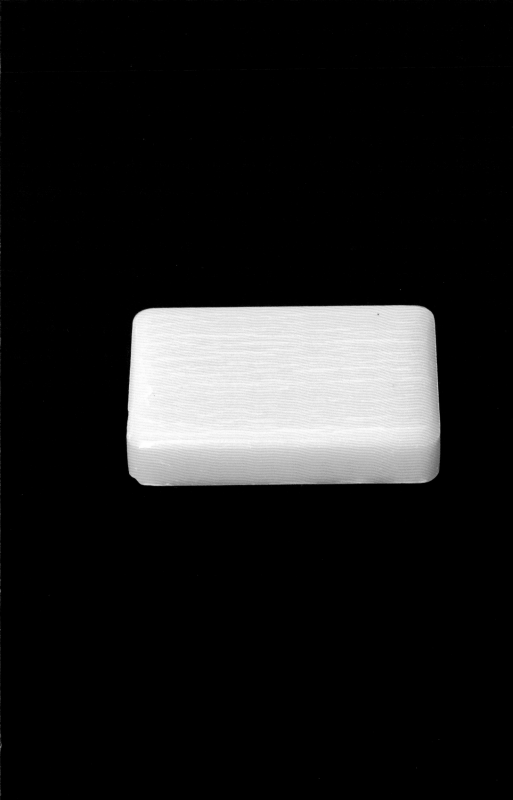

Robert Gober
Plywood, 1987

Ugo Rondinone
Clockwork for Oracles II, 2008

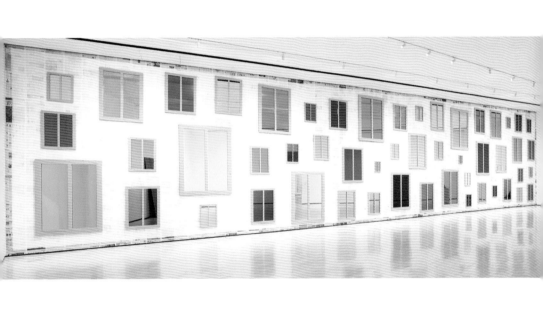

Marcel Duchamp
Miroir (Mirror), 1964

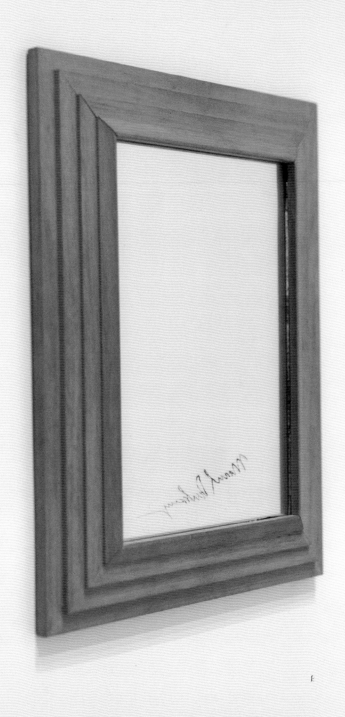

Ian Wilson
There was a discussion with Lucy Lippard in New York City
(11th Avenue) in 1969, 1969

There was a discussion with Lucy Lippard in New York City
(11th Avenue) in 1969.

Ian Wilson

Ian Wilson

There were discussions in Dusseldorf in 1970, 1970

There were discussions in Dusseldorf in 1970.

Signed: Ian Wilson

Ian Wilson
There was a discussion at the Galleria Toselli in Milan,
March 30, 1973, 1973

There was a discussion at the Galleria Toselli in Milan,
March 30, 1973.

Ian Wilson

Luca Francesconi
Alpes de Gressoney, 1500m, Vallée d'Aoste, 2005

Monte Turchino, 682m, Ligurie, 2005

Monte Kusna, 2121m, Emilie-Toscane, 2005

All from the series *Abbassare le Montagne*
(To Lower the Mountains)

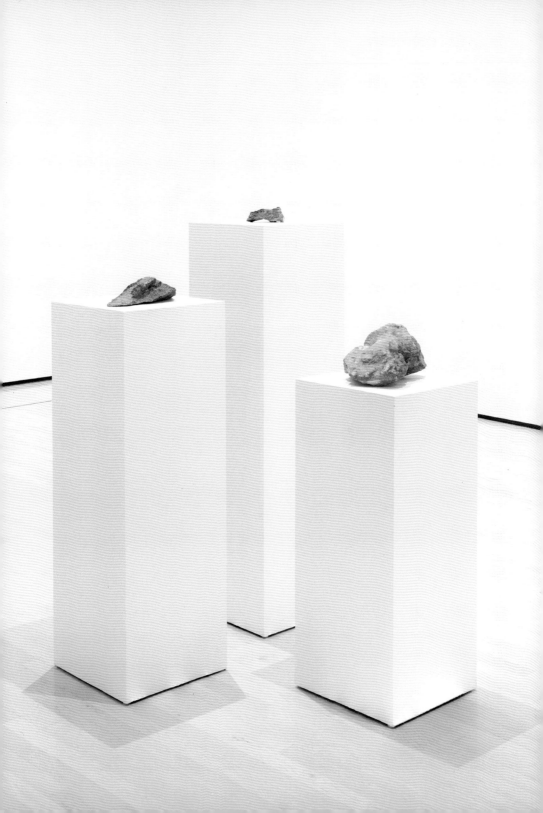

Wolf Vostell
Betonbuch (Concrete Book), 1971

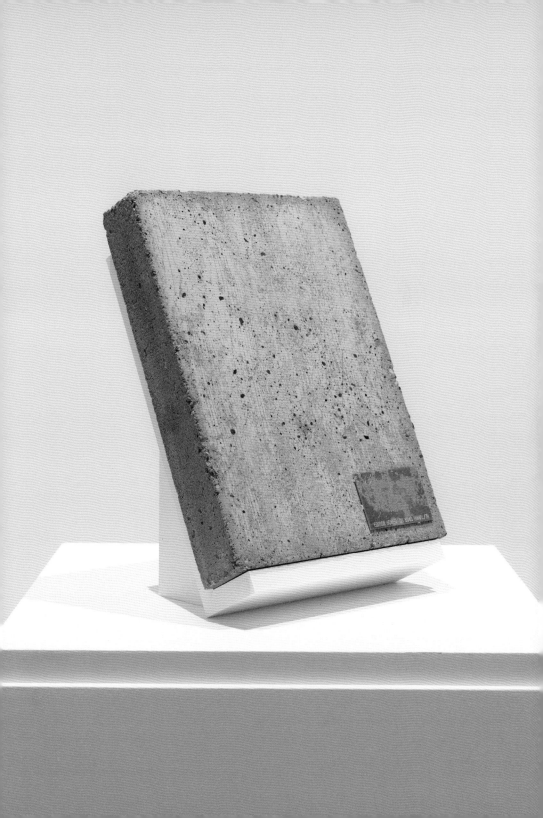

Jonathan Monk
Second Hand Daily Exchange, 2006

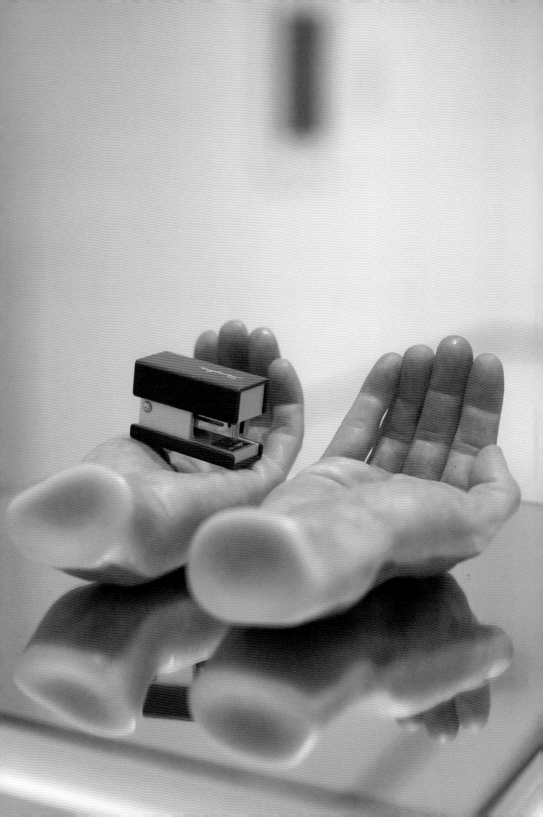

Tony Matelli
Weed (#370), 2016

Tony Matelli
Weed (#384), 2017

Tony Matelli
Weed (#337), 2014

Unknown
Seated Bishop, Late 14th century

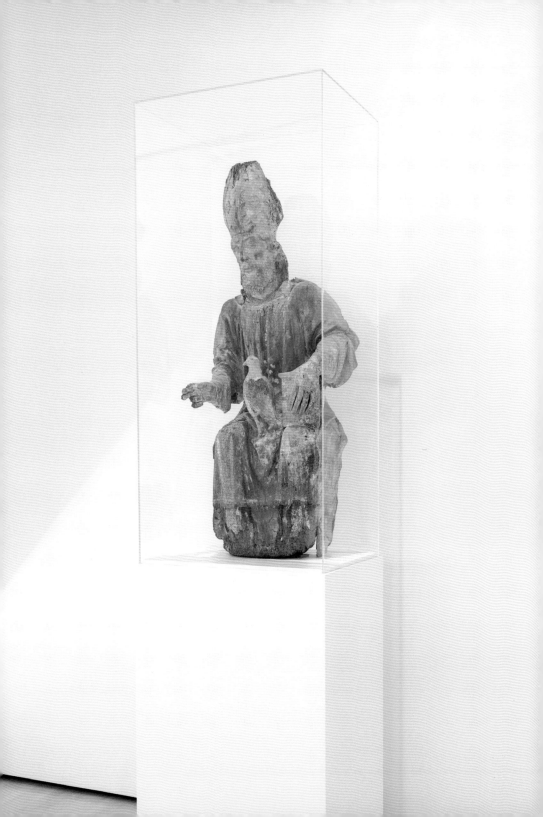

Georges Méliès
Match de prestidigitation (A Wager between Two Magicians), 1904

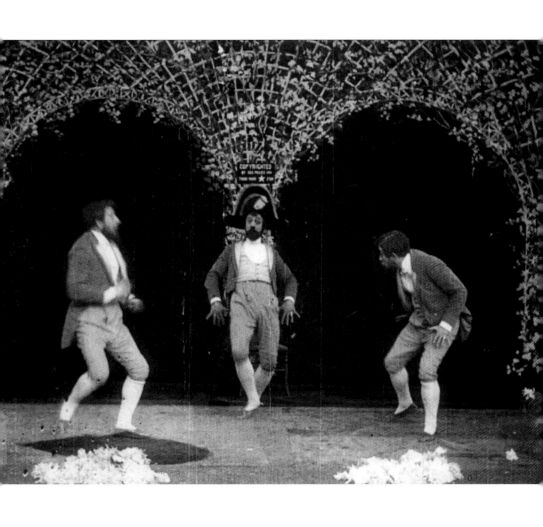

Charlotte Posenenske
Series D Vierkantrohre (Series D Square Tubes), 1967–2007

Christian Jankowski
What Could Possibly Go Wrong?, 2017

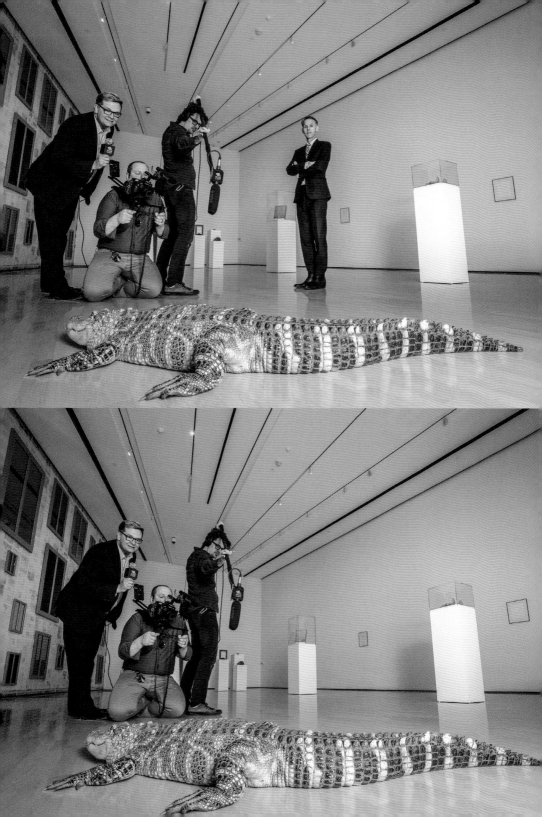

Leopold Kessler
Sodamachine a and b, 2006

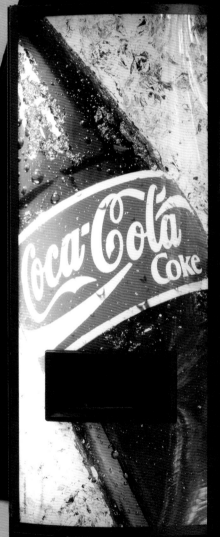

Urs Fischer
Hands, 2002

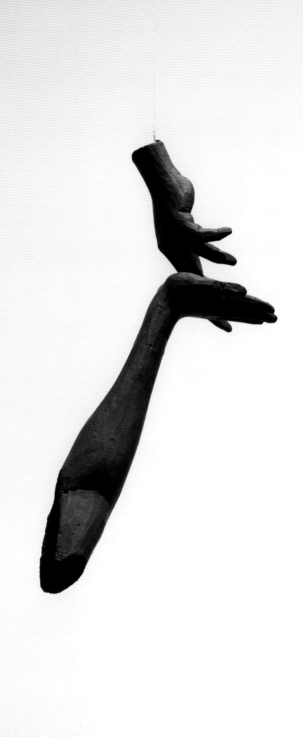

Piero Manzoni

Base magica—Scultura vivente (Magic Base—Living Sculpture), 1961

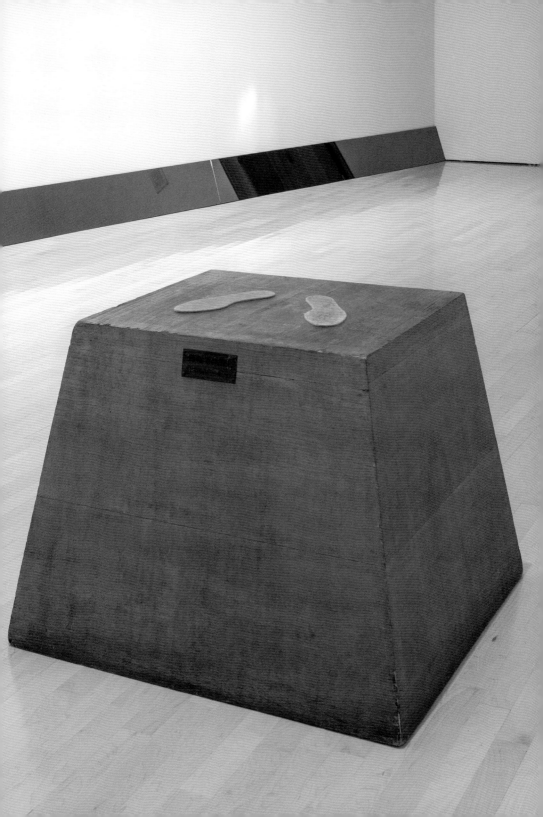

Urs Fischer
Untitled, 2015

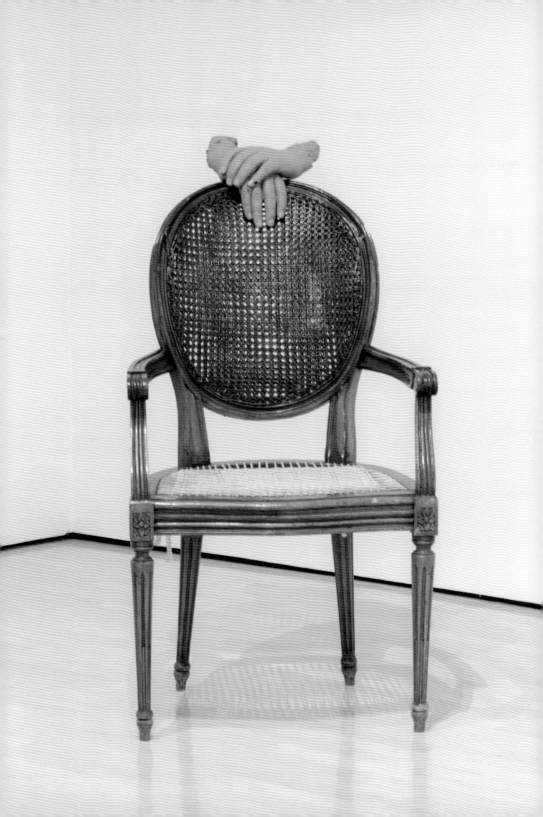

Arcangelo Sassolino
Piccole Guerre (Little Wars), 2016

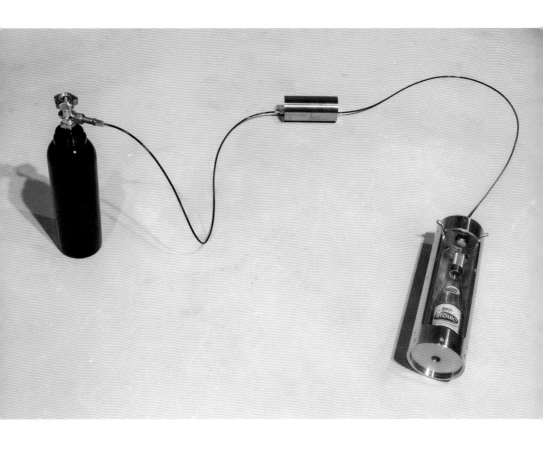

Adam McEwen
Shoegazer, 2002

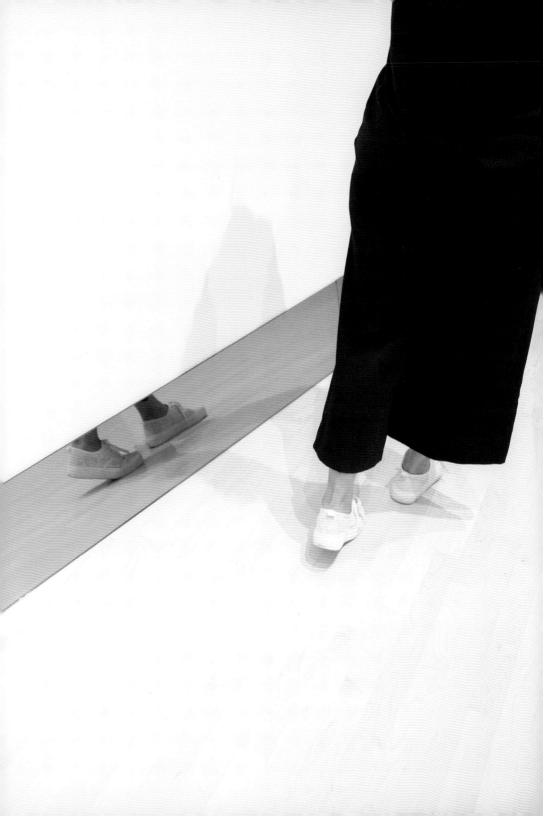

Robert Gober
Drains, 1990

Oscar Tuazon
Rooms, 2012

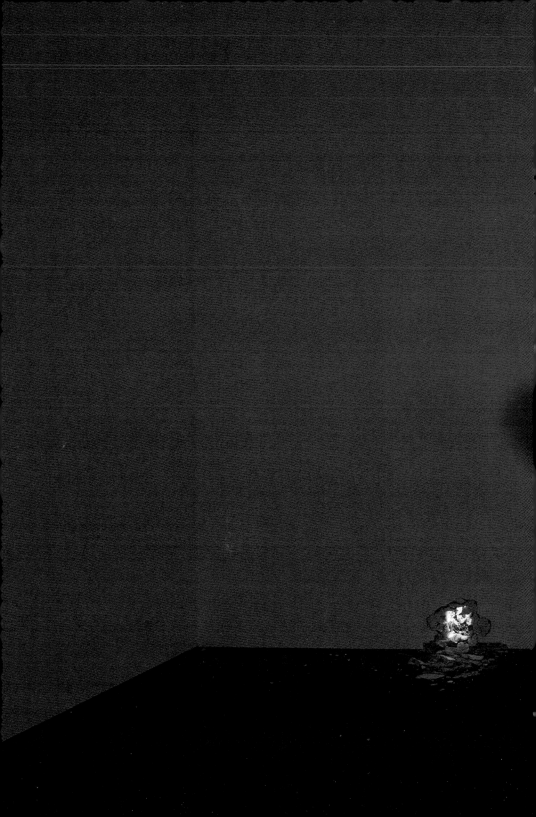

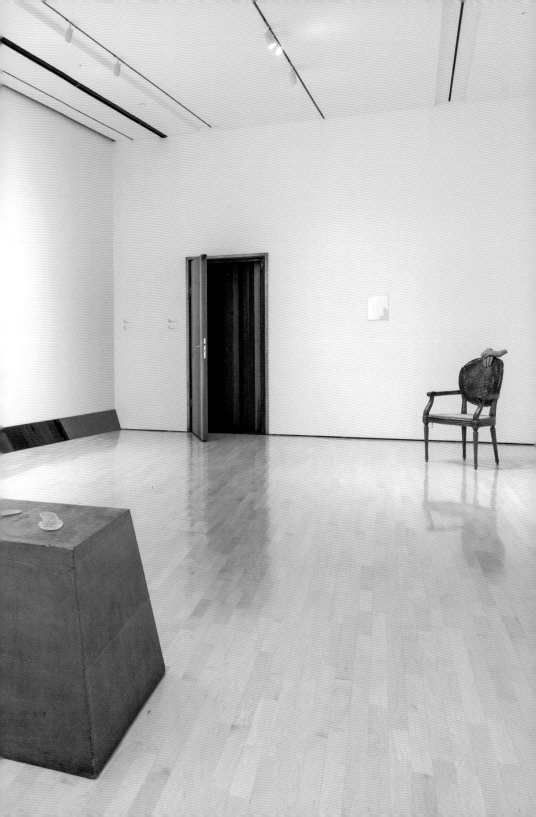

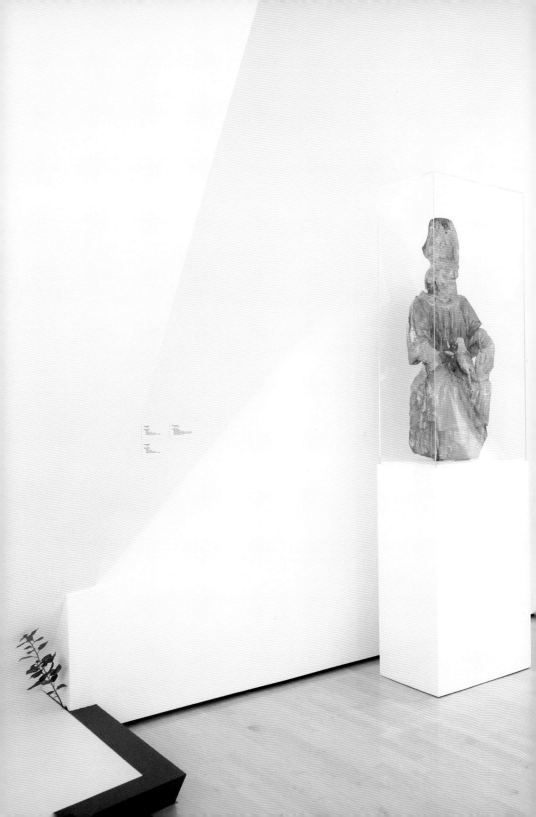

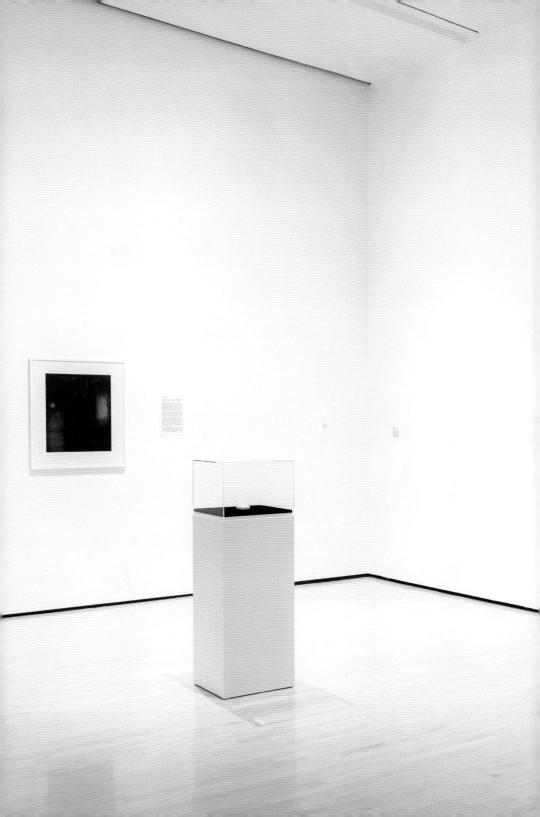

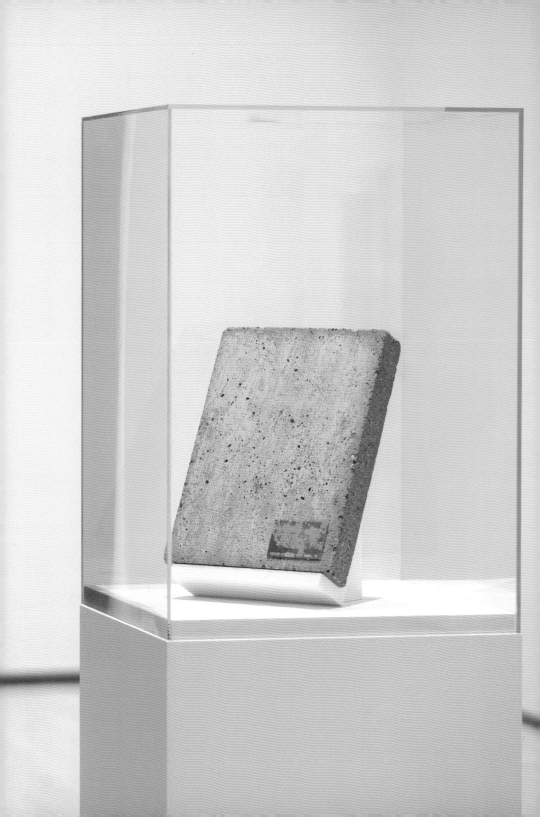

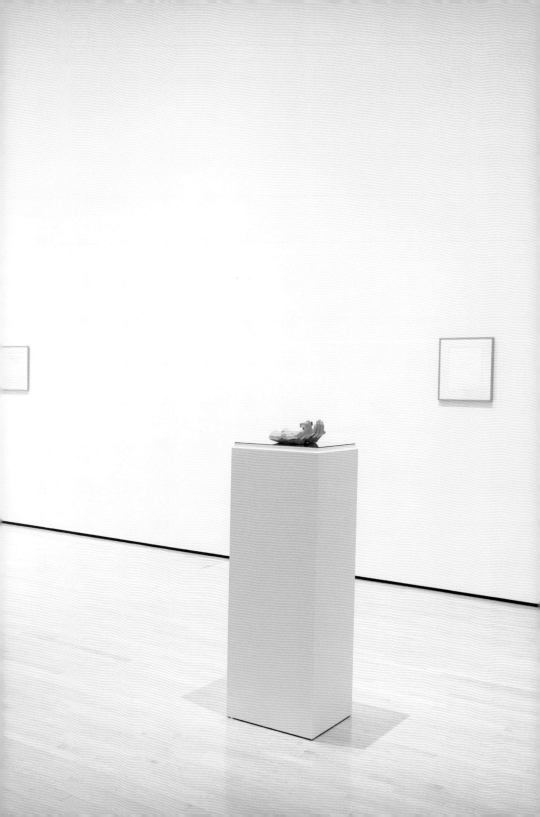

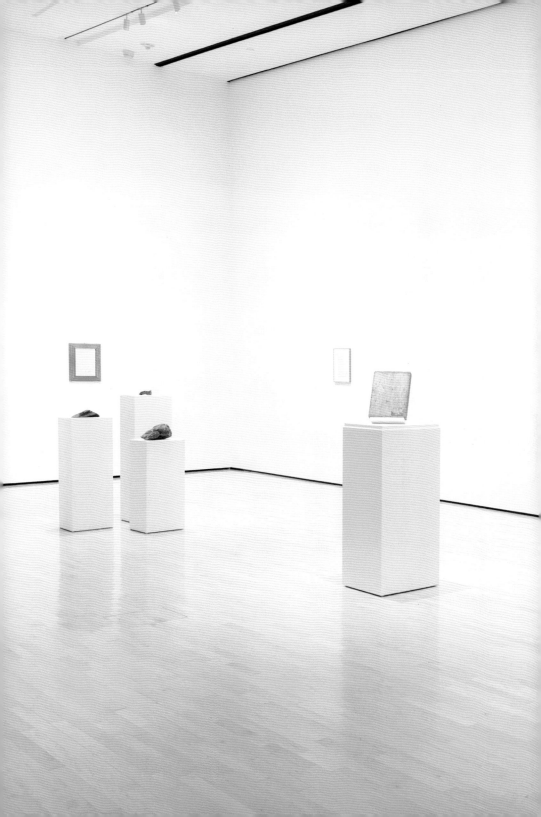

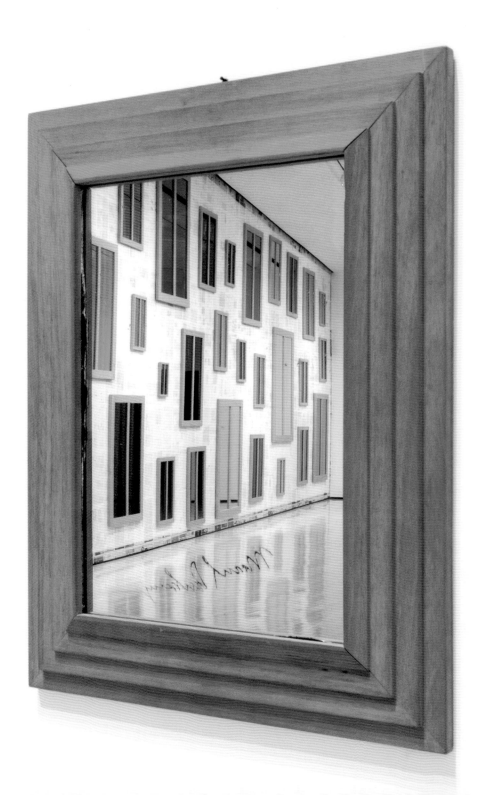

THE THINGS

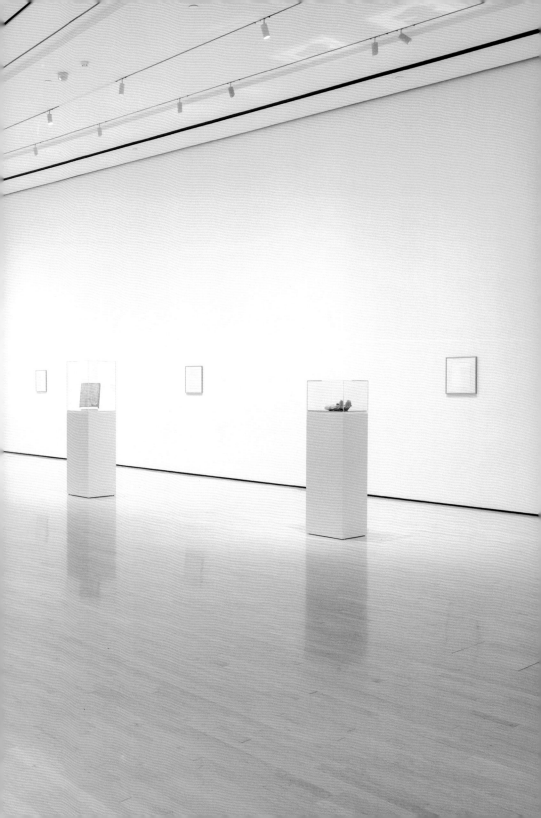

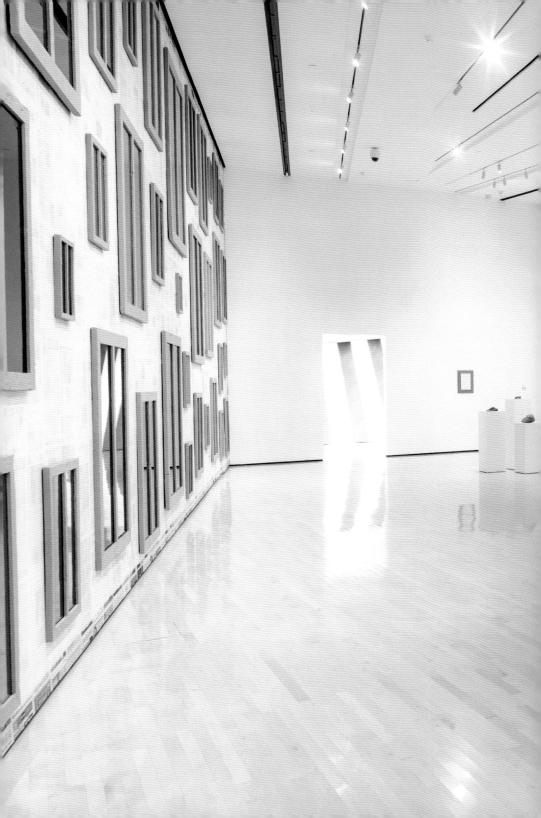

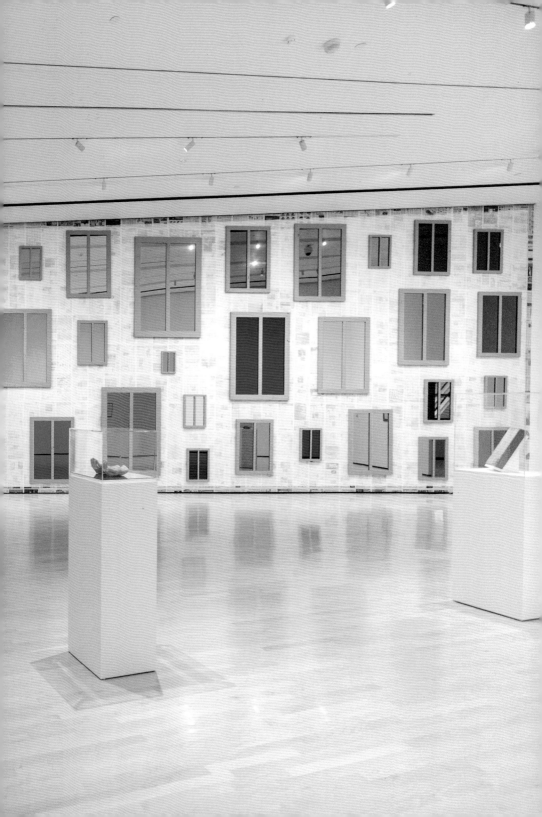

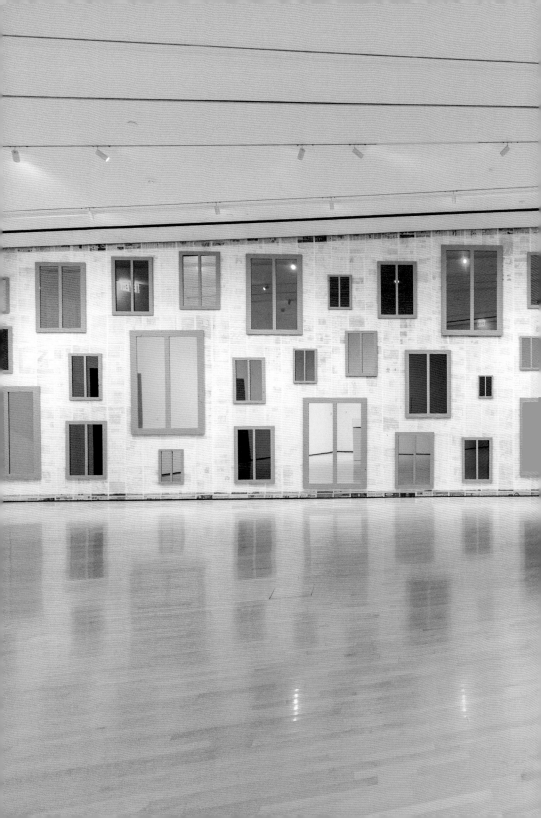

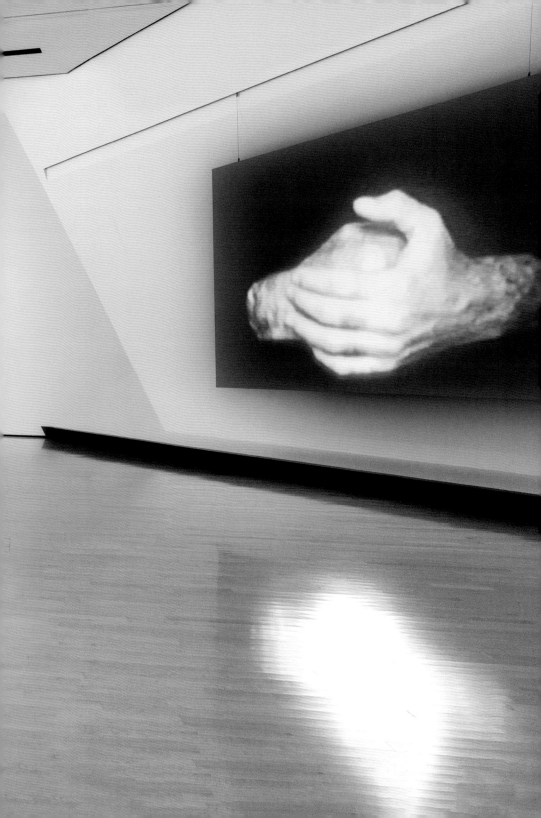

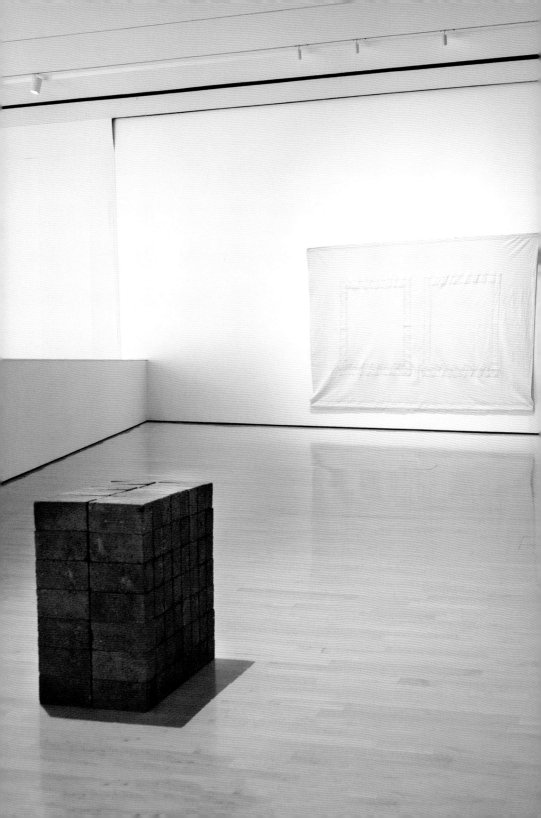

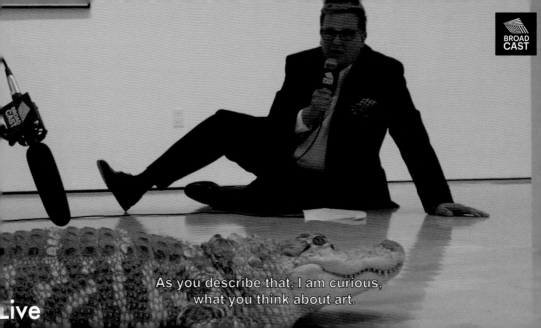

As you describe that, I am curious,
what you think about art.

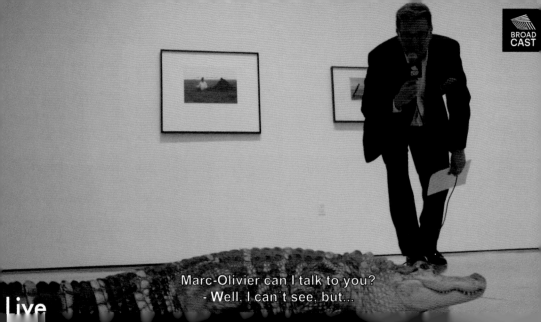

and swallowed him
in one whole piece!

Live

The gator just threw
Marc-Olivier up in the air...

Live

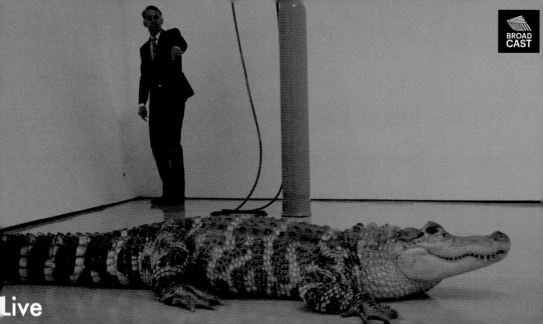

Live

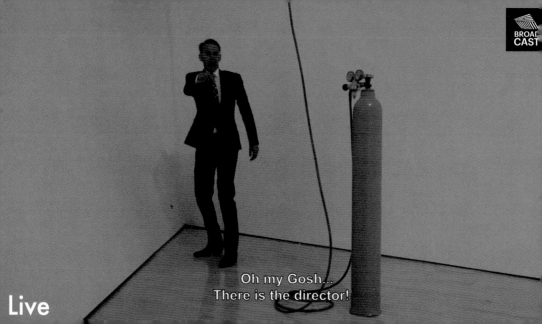

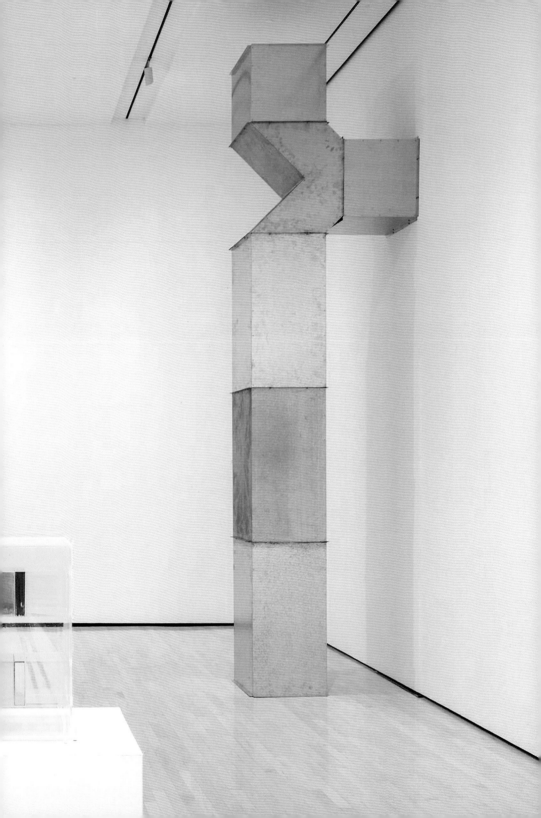

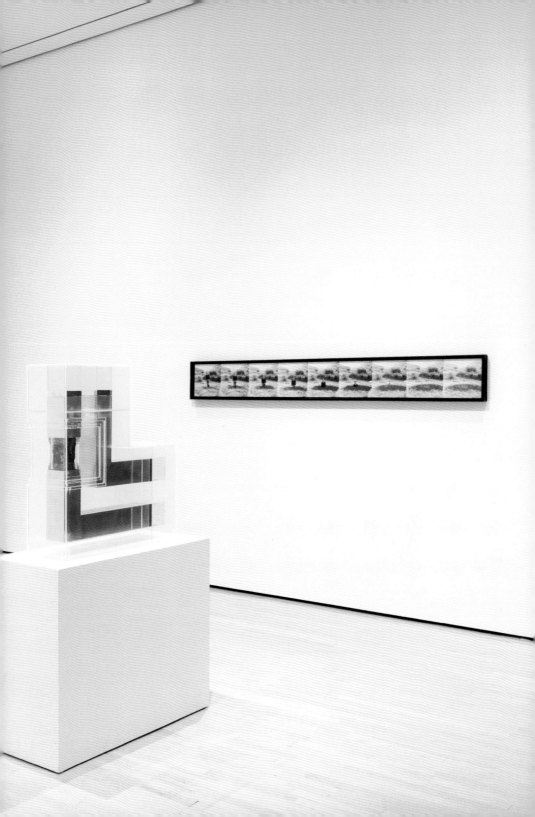

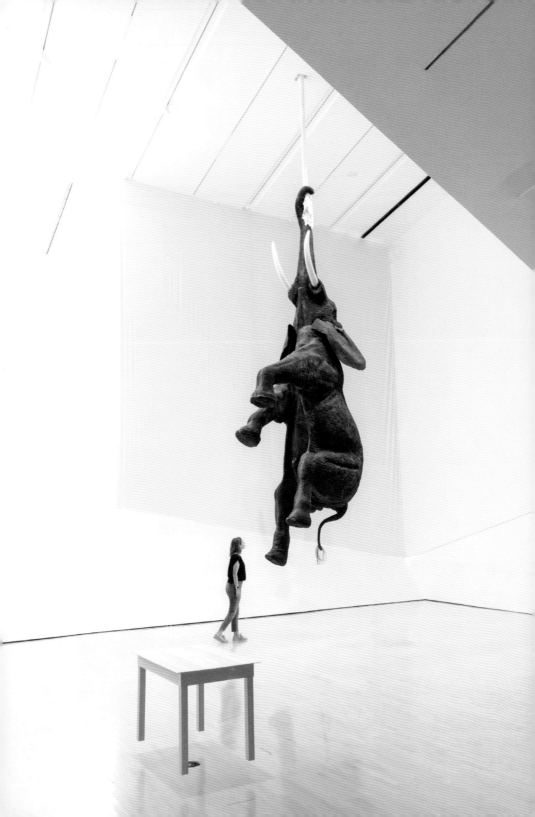

THE THINGS

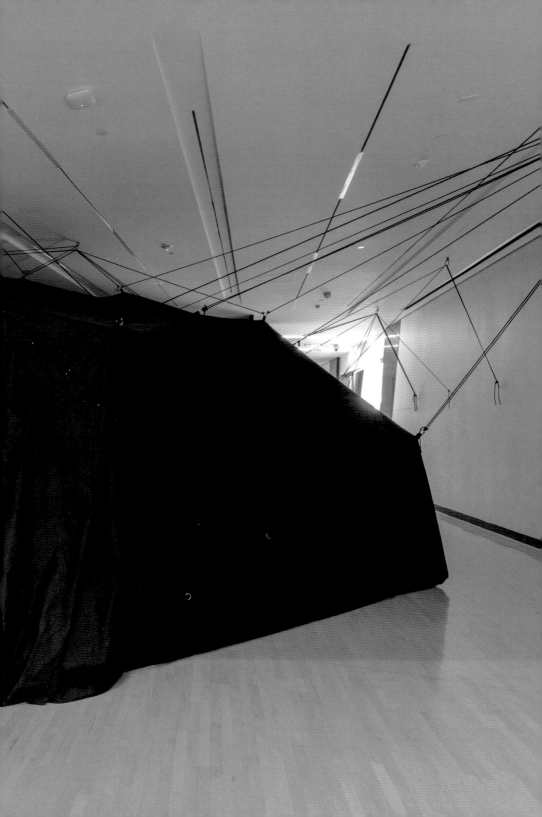

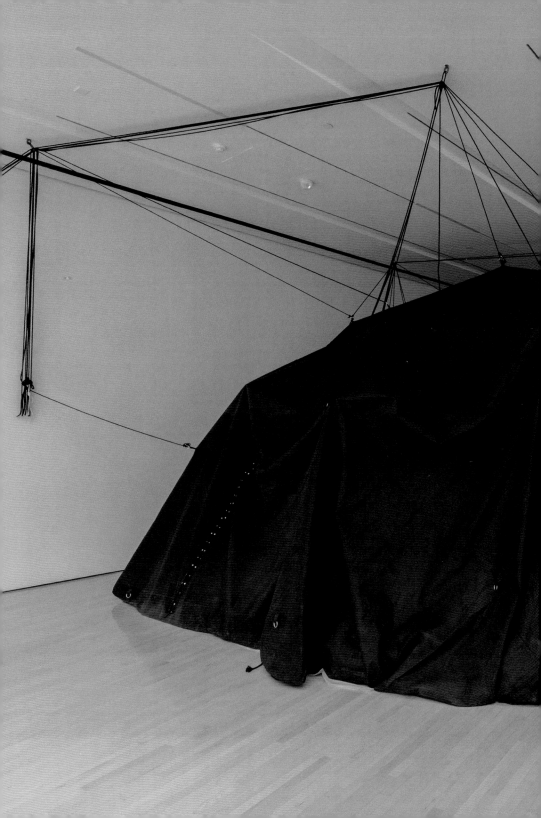

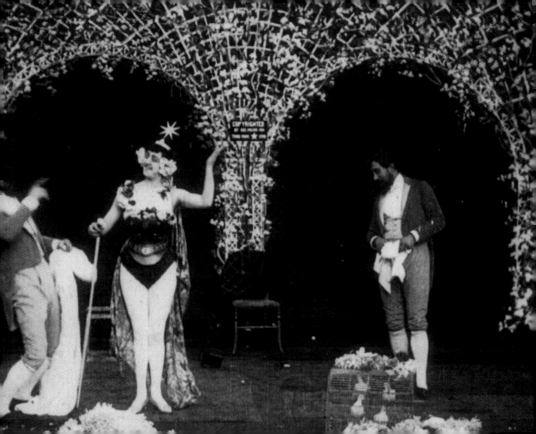

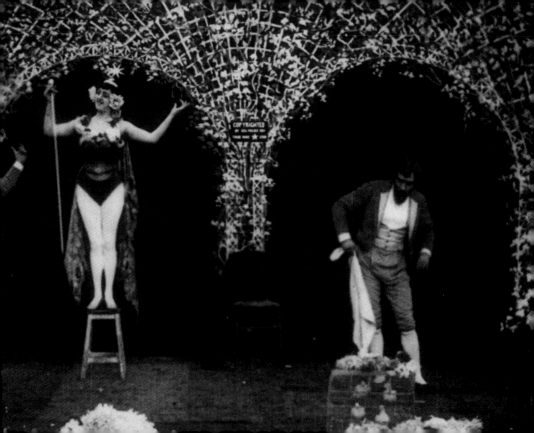

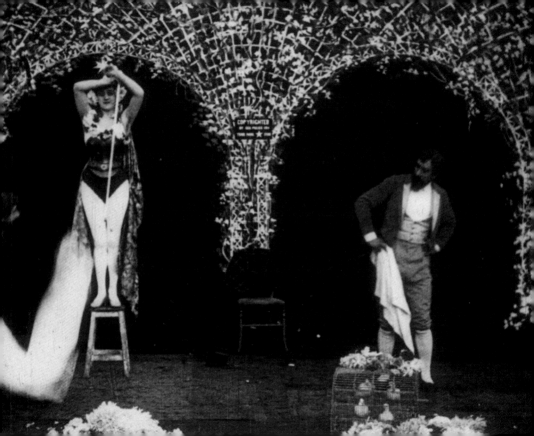

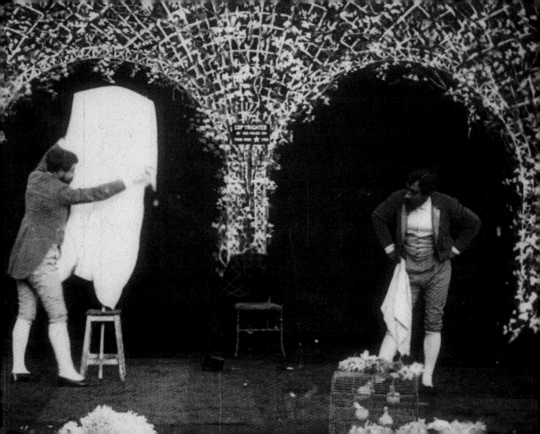

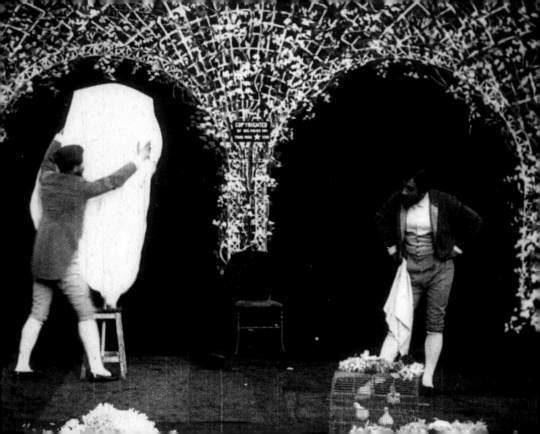

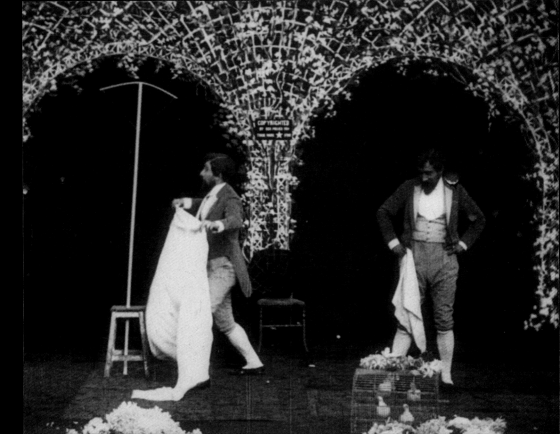

...

Letter to Andre Breton

June 27, 1946

Dear Friend,

As a postscript to my last letter: I have been thinking about what you said about Magic. You are respecting the "fixed forms," which have been proven by experience. I would be at your side to defend them, as long as this traditional magic is able to resist or adamantly fight the behaviors and beliefs of "reasonable" people. That is also why I like the sign of rebellion that the "feminine principle" represents. It would be easy for me now to love such an activity, because it looks like mine, which makes me forget about having to be efficient. Today I see our pleasure as a goal, whereas before it was all about turning the outside world upside down. Here is how I understand utopia: it is not a dream that happens in the future, but utopia is locating the golden age within the boundaries of our own lives. Apart from the appalling use of Magic, I have to say that it is useless to me personally (except for poetic Magic). It should be forgotten like old habits and traditions, old religions, and all mediocrities of the mind that feed on symbols. I believe you are no more afraid of being bewitched by a sorcerer than of being excommunicated by the Pope? I hope to see you soon, your friend,

Magritte

 See page 110 in The Objects

Découverte à Prague d'un film de Méliès

Un film de Georges Méliès (1861-1938), intitulé *Match de prestidigitation,* sorti en 1904 et considéré comme perdu, a été retrouvé par les chercheurs des Archives nationales du film (NFA) à Prague, qui l'ont fait savoir mardi 11 octobre. Le film se trouvait sur une bobine offerte aux NFA par un collectionneur tchèque souhaitant garder l'anonymat. *« La bobine était intitulée "Les Transmutations imperceptibles", ce qui est le titre d'une autre œuvre de Méliès. Mais notre spécialiste a immédiatement su qu'il s'agissait d'un autre film »,* a déclaré à l'AFP la porte-parole des NFA, Jana Ulipova. D'une durée d'environ deux minutes, le film montre un magicien qui se dédouble. Les deux magiciens, chacun de son côté, rivalisent ensuite de tours amusants, puis ils se réconcilient et se fondent en un seul homme.

Georges Méliès a tourné quelque 500 films, dont le *Voyage dans la Lune* (1902). Un peu moins de la moitié a été conservée. – *(AFP.)*

A Film by Méliès Discovered in Prague

A film by Georges Méliès (1861–1938), titled *Match de Prestidigitation* ("A Wager between Two Magicians"), released in 1904 and thought to be lost, was found by researchers at the National Film Archive (NFA) in Prague, which made the announcement on Tuesday, October 11[, 2016]. The film was found on a reel given to the NFA by a Czech collector who wishes to remain anonymous. "The reel was titled '*Les Transmutations Imperceptibles,*' which is the title of another work by Méliès. But our specialist immediately knew this was another film," Jana Ulipova, the NFA's spokesperson, told AFP. Approximately two minutes long, the film presents a magician who duplicates himself. The two magicians, each occupying half of the screen, compete by performing entertaining tricks; then they reconcile and merge into a single man. Georges Méliès made some five hundred films, including *Voyage dans la Lune* (1902). A bit more than half have been conserved.

Agence France-Presse (AFP)
Le Monde
October 13, 2016

 See page 88 in The Objects

their magic ventures. While Uriel, Madimi, Ath, and the other angels they summoned were more friendly and cooperative than the demon Choronzon, Dee's notes can be read as a list of disappointments. The angels made promises and—even more so—demands, but no matter what actions Dee and Kelly took to accommodate their shifting moods, uncertainty prevailed. The hidden mechanisms by which the world operates were contrary to divine assurances never revealed. Despite the use of the new and elaborate "celestial" Enochian language, the otherworld remained as haphazard as the world itself, and following the advice of the angels led to random or at least surprising results. Dee ended his life isolated and poor, while Kelly, most likely, fell to his death during an attempt to escape imprisonment.

Today part of the lengthy manuscripts that once made up the Enochian works can be found at the British Library. The crystal ball and the black mirror used in the séances are exhibited in a showcase in the British Museum. Here, the imperial architecture of the museum is reflected in miniature by the crystal ball, while the visitor's gaze is greeted by a dark absence when it encounters the mirror—a blank surface that, although mute, seems to emanate a narrative persistence, a sleeping presence, not unlike a photograph.

– Joachim Koester

 See page 58 in The Objects

The Magic Mirror of John Dee

There is a way of seeing that does not rely on the eyes. It emerges in the state between wakefulness and dream, when patterns and shapes flash behind the eyelids, or as visions, trance-induced while gazing into a crystal ball or at a black mirror.

John Dee (1527–1608), scientist, astrologer, and owner of the biggest book collection in England, did not possess this "second sight" but hired necromancer Edward Kelly—earless after a conviction for forgery—as his medium. Together, over a period of seven years, they conducted a number of magical séances, which became known as the Enochian Works. Enveloped in trance, Kelly would stare into a crystal ball or a black glass, apprehending images and messages from the otherworld. At his side, Dee would transcribe the events with utmost precision. Slowly, through these works, a "long-lost" language called Enochian materialized; a magical system of evocations and a mapping of a mental landscape with numerous celestial cities inhabited by angels, and, farther out, beyond four watchtowers, swarms of demons.

It was one of these gates of the mind that Aleister Crowley—who believed he was the reincarnation of Kelly—opened with the help of poet Victor Neuburg in the North African desert near the village of Bou Saada in 1909. By means of an Enochian ritual that lasted for days, Crowley conjured Choronzon, better known as the death-dragon. The demon rose from the abyss of meaningless forms to momentarily possess Crowley and terrify Neuburg, who had to fight off the attacking Crowley (or Choronzon) with a magical dagger. Neither Dee nor Kelly were unequivocally successful in

'Berlusconi's fat'

An artwork purportedly made from excess fat from Italian Prime Minister Silvio Berlusconi has been sold for $18,000 (£9,862).

Switzerland-based artist Gianni Motti claims to have bought the fat from a clinic where the leader had a liposuction operation performed.

He molded it into a bar of soap which he named *Mani Pulite* (Clean Hands).

The work was put on display at the Art Basel fair in Switzerland and was sold to a private Swiss collector.

Motti gave it the title *Clean Hands* as a reference to an anticorruption campaign of the 1990s. It reflects the artist's view of the current government.

"I came up with the idea because soap is made of pig fat, and I thought how much more appropriate it would be if people washed their hands using a piece of Berlusconi," Motti told *Weltwoche* magazine.

Motti's work was part of the display from the Galerie Nicola von Senger of Zurich, one of 270 worldwide galleries exhibiting contemporary works.

All the works on display were for sale, with prices topping $45,000 (£24,658) as collectors hope to uncover the big names of the future.

BBC News
June 20, 2005

See page 60 in The Objects

THE THINGS

· · ·

does not allow it to become muddled by the waves, merely reduced. So that when vanquished it finally becomes sand, water can still not penetrate it as it penetrates dust. Keeping all traces except those of liquid, which limits itself to trying to erase all other traces, it lets the whole sea filter through, which disappears into its depths without in any way being able to make mud out of it.

• • •

I shall say no more, for this idea of signs disappearing makes me reflect on the faults of a style that relies too much on words.

Only too happy to have chosen for these beginning *the pebble*: for a man of wit cannot fail to be amused, and also moved, when my critics say: "Having undertaken to write a description of stone, he got buried under it."

Water on the other hand, which makes everything slippery and spreads its fluidity to whatever it can encompass, sometimes manages to seduce these forms and carry them off. For the pebble remembers it was born of the thrusts of these formless monsters against the equally formless monster of stone.

And since its individuality can only be accomplished by repeated application of liquid, it remains by definition forever amenable to it. Lackluster on the ground, as day is lackluster compared to night, the moment the wave takes hold of it, it starts to shine. And though the wave works only superficially, barely penetrating the very fine, hard-packed agglomerate, the very thin though active adherence of the liquid causes a noticeable modification of its surface. As though the water were repolishing it, thus assuaging the wounds of their earlier embraces. Then for a moment, the pebble's exterior resembles its interior; all over its body it has the sheen of youth.

Its perfect form is equally comfortable in either environment, remaining imperturbable in the sea's confusion. The pebble simply comes out of it a bit smaller, but intact, and just as *great* since its proportions in no way depend on its volume.

Once out of the water, it dries immediately. Which is to say that despite the monstrous efforts to which it was subjected, no trace of liquid can remain on its surface; the pebble with no effort does away with it.

In short, smaller from the day to day but always sure of its form; blind, solid, and dry within; its nature

pebble takes up residence on ground formed by their seed, where the bulldozing sea seeks and loses it.

But these places to which the sea generally relegates it are the least suited to granting recognition. Whole populations lie there known only to the expanse, each pebble considering itself lost because it is unnumbered and sees only blind forces taking note of it.

In fact, wherever such flocks lie down they all but cover the ground completely, and their backs form a floor as awkward for the foot as for the mind.

No birds. Here and there are a few blades of grass between the pebbles. Lizards scramble over them indifferently. Grasshoppers measure themselves rather than the pebbles with their leaps. Every now and again, a man distractedly tosses one far out.

But these objects of scant value, lost without order in a solitude broken by dune grass, seaweed, old corks, and other debris of human provisions—imperturbable amid the greatest upheavals of the atmosphere—are mute spectators of these forces that run blindly after anything and for no reason until exhausted.

Rooted nowhere, they remain in their haphazard spot on the expanse. A wind strong enough to uproot a tree or knock down a building cannot displace a pebble. But since it does raise up dust, the whirlwind sometimes ferrets one of these landmarks of chance out of their haphazard places, for centuries under the opaque and temporal bed of the sand.

• • •

tials of this world. There is no conception: everything exists. Or rather, as in paradise, all conception exists.

• • •

If I now wish to examine a specific type of stone with greater attention, its perfection of form and the fact that I can hold it, roll it around in my hand, makes me chooses the pebble.

Furthermore, the pebble is stone at precisely that stage when it reaches the age of the person, the individual, in other words, the age of speech.

Compared to the rocky ledge from which it is directly descended, it is stone already fragmented and polished into many nearly similar individuals. Compared to the finest gravel, one can say that because of where it is found and because not even man puts it to practical use, the pebble is stone still wild, or at least not domesticated.

For the remaining days without meaning in a world with no practical order, let us profit from its virtues.

• • •

Brought one day by one of the tide's countless wagons, which seem to unload their useless cargo just for the sound of it, each pebble rests on a pile of its past and future forms.

Not far from places where a layer of loam still covers its enormous forebears, beneath the rocky ledge where its parents' love act still goes on, the

So that contrary to popular opinion, which makes stone in man's eyes a symbol of durability and impassiveness, one might say that stone, which does not regenerate, is in fact the only thing in nature that constantly dies.

And so when life, through the mouths of beings who successively and briefly get a taste of it, pretends to envy the indestructible solidity of its setting, the truth is it contributes to the continual disintegration of that setting. It is this unity of action that life finds so dramatic: it mistakenly believes that its foundation may one day fail it, while believing itself to be eternally renewable. Placed in a setting that has given up being moved, and dreams only of falling into ruin, life becomes nervous and agitated about knowing only how to renew.

At times stone itself seems agitated. This is in its final stages, when, as pebble, gravel, sand, dust, it can no longer play its part as container or supporter of living things. Cut off from the original block, it rolls, flies, demands a place on the surface, and all of life retreats from the drab expanses where the frenzy of despair alternately scatters and reassembles it.

Finally, I would like to mention a very important principle, namely, that all forms of stone, all of which represent some stage of its evolution, exist simultaneously in the world. No generations, no vanished races here. Temples, Demigods, Wonders of the World, Mammoths, Heroes, Ancestors, live in daily contact with their grandchildren. Any man in his own garden can touch all the fully fleshed poten-

her arms; sifts, kneads, flattens, smoothes against her body; or leaves in a corner of her mouth like a Jordan almond, which she later takes out and places on some gently sloping shore within easy reach of her already sizeable collection, with the idea of picking it up soon again and caring for it even more affectionately, even more passionately.

Meanwhile, the wind blows, making the sand whirl. And if one of these particles—last and smallest form of the object under consideration—happens to enter our eyes, it is in this way—its own blinding way—that stone punishes and terminates our contemplation.

Nature thus closes our eyes when it comes time to ask of memory whether the information gathered there by prolonged contemplation has not already provided it with a few principles.

• • •

To the mind in search of ideas, which has first been nourished on such appearances, nature in terms of stone will ultimately appear, perhaps too simplistically—like a watch whose mechanism consists of wheels turning at different speeds though run by the same motor.

To die and live again, plants, animals, gases, and liquids move more or less rapidly. The great wheel of stone seems to us practically, and even theoretically, immobile; we can only imagine a portion of its slowly disintegrating phase.

In these same places, numerous smaller blocks attract his attention. Sprinkled in underbrush by Time are odd-sized stonecrumbs, rolled between the dirty fingers of that god.

Ever since the explosion of their enormous forebear and their trajectory into the skies felled beyond redress, the rocks have kept silent.

Invaded and fractured by germination, like a man who has stopped shaving, furrowed and filled with loose earth, none of them, now incapable of any reaction at all, makes a sound any longer.

Their faces, their bodies are lines. Naiveté draws close and settles in the wrinkles of experience. Roses sit on their gray knees and launch their naive diatribe against them. And they let them, they whose disastrous hail once lit up forests, whose duration in stupor and resignation is eternal.

They laugh to see around them so many generations of flowers born and condemned, whose coloring, whatever one says, is hardly more vivid that theirs, a pink as pale as their gray. They think (like statues, not bothering to say it) that these hues were borrowed from the rays of the settling sun, rays donned by the skies every evening in memory of a far brighter fire—that famous cataclysm during which they were hurled violently into the air and enjoyed an hour of stupendous freedom brought to an end by that formidable crash. Nearby, at the rocky knees of the giants watching from her shores the foaming labors of their fallen wives, the sea endlessly tears off blocks which she keeps, hugs, cradles, dandles in

life of millions of beings infinitely smaller and more ephemeral. In places, their crowding is so dense it completely hides the sacred skeleton that was once their sole support. And it is only the infinite number of their corpses, having succeeded from that time in imitating the consistency of stone with what is called organic soul, that permits them of late to reproduce without owing anything to the rock.

Then, too, the liquid element, whose origin is perhaps as ancient as that of the element under discussion, having collected over greater and lesser areas, covers it, rubs it, and by repeated abrasion encourages erosion.

I shall now describe some of the forms that stone, currently scattered and humbled by the world, offers for our examination.

• • •

The largest fragments—slabs almost invisible under the entwining plants that cling to them as much for religious as for other motives—make up the global skeleton.

These are veritable temples: not constructions arbitrarily raised above the ground, but serene remains of the ancient hero who was really in the world not long ago.

Given to imagining great things amid the shadows and scents of the forests which sometimes cover the mysterious blocks, man by thought alone infers their continued existence beneath him.

around it have let themselves be eclipsed. But in order for the truth—whose glory they relinquish in behalf of its very source—to retain an audience and objects, already dead or about to be, they nonetheless continue to orbit around it and serve as spectators.

One can imagine that such a sacrifice—the expulsion of life from natures once glorious and ardent—was not accomplished without some dramatic inner upheavals. There you have the origin of gray chaos of the Earth, our humble and magnificent abode.

And so, after a period of twists and turns, like a sleeping body thrashing under blankets, our hero, subdued (by his consciousness) as though by a gigantic straitjacket, no longer felt anything but intimate explosion, less and less frequent, with shattering effects on a mantle that grew heavier and colder.

Deceased hero and chaotic Earth are nowadays confused.

• • •

The history of this body—having once and for all lost the capacity of being aroused in addition to that of recasting itself into a total entity—ever since the slow catastrophe of cooling, will be no more than a history of perpetual disintegration. But at this very moment other things happened: with grandeur dead, life at once makes clear that the two have nothing in common. At once, in countless ways.

Such is the globe's appearance today. The severed cadaver of the being that was once the world's grandeur now serves merely as a background for the

FRANCIS PONGE

A pebble is not an easy thing to define.

If one is satisfied with a simple description, one can start out by saying it is a form or state of stone between rock and gravel.

But this remark already implies a notion of stone that has to be justified. On this subject let me not be reproached for going even farther back than the Flood.

• • •

All rocks are offsprings through fission of the same enormous forebear. All one can say about this fabulous body is that once outside of limbo it did not remain standing.

When reason gets to it, it is already amorphous and sprawling in the doughy heavings of the death agony. Awakening for the baptism of a hero of the world's grandeur, reason discovers instead the ghastly trough of a death bed.

Let the reader not rush through this, but take the time to admire—instead of dense funereal expressions—the grandeur and glory of a truth that has managed, whatever the degree, to render these expressions transparent yet not obscure itself completely.

This is how, on a plant already drab and cold, the sun presently shines. There is no flaming satellite to dissemble this fact any longer. All glory and all existence, everything that grants vision and vitality, the source of all objective reality has gone over to the sun. The heroes it engendered who gravitated

134

Taking the Side of Things

simple thing and exist elsewhere than in the institutional context of art.

CK To end, can we turn back to belief, but in the context of ontology and not in that of magic anymore? Which means asking oneself the following question: Can one comprehend the art object without belief?

MOW There is no art object without belief, whether that belief is produced by the institution, by the language that grasps it, by semiology, or by logic, to use the terms that Danto applied to transfiguration. But in what concerns me, and for the exhibitions I realize, I would like it to rest on something simple, which serves as the base for the construction of all belief: a narrative system that involves an object, a form, a story. That capacity to tell stories, which is an essential fact and a founding event in the history of humankind, entails a strong belief in fiction. But art is a particular fiction because it offers a critical system that allows one to believe differently, or even to no longer believe: art multiplies systems of belief, it functions as a muscle that strengthens our possibilities and our means of believing.

between those polarities. . . and also a matter of reappearance, to get back to the impetus behind [the *Transported Man*] exhibition.

MOW I find that movement very interesting because the question *where* introduces the spatial dimension, in the geographical sense, to disappearance and reappearance. It also integrates the physical dimension of the work with the viewer's: that involves the place in which one finds oneself but also our own physical reality, our own way of perceiving, seeing, moving about, and acting. Those contextual dimensions fully partake of ontology, and they exceed solitary conceptual considerations. At that point, I think we're touching on precisely what interests artists.

CK That could also introduce a topology: where does it start and to where does it extend?

MOW Art has to be implemented in one way or another, but the best exhibition, to me, is the kind that begins to exist in another way as soon as you leave your physical place. The exhibition is a tool that animates the mind of the viewer and moves with him in other contexts to modify his way of seeing. It's very important to me to consider art as a tool that allows us to see reality differently. That conception of the exhibition echoes the preoccupations of some ontologists (like [French philosopher] Tristan Garcia, for example) and attempts to remain faithful to Duchamp's project and those of many other artists, taking note of the determination of the object. From there, two paths are possible: One is to try to empty the object of all determination, as several have tried to do, especially in the 1960s and 1970s—with mixed success in my opinion. "What you see is what you see," to cite Frank Stella. Another goes in the opposite direction: increasing the determinations of the object, which means conceiving of objects with what I call a high "schizophrenic quotient," which calls for forever revived approaches to the point that all interpretations are of equal merit on a horizontal plane, without determination. To paraphrase Tristan Garcia, the object is left in its solitude, a condition that favors its surreptitious shift, while being looked at, toward a formal plane, a flat and bare surface. Escaping all objectification at that point, it can become a

Society as research on what an artist, exhibition, or work might be. We can certainly agree on the fact that we are in front of an artist, a work, or an exhibition; but what happens concretely when certain rules, codes, or conventions that allow us to canonically identify those things are broken? Following those experiments, my interests shifted, and that inquiry is now focusing on the space between the ordinary object and the work of art—a place of tension and constant movement. And in my opinion, the best tool we have to conduct such an inquiry is magic, with its in-between quality and the ambivalent belief that characterizes it.

But the great challenge for an artwork, in terms of the operation of transfiguration, is to be able to return from point B to point A: to pull away from the artwork, draw near to the ordinary object, and be able to invest that infinite space between two poles, two fixed points. That's the entire drama of Duchamp, who quickly realized how easy it was to go from point A to point B, and who for the rest of his life sought to turn back—in other words, to go from point B to point A—while declaring he wasn't an artist but rather an engineer, that he wasn't making art, etc. In my mind, he succeeded, but the public simply

wasn't ready yet to follow him. The paradox of art today is that all artists seek a position between those two poles, but the public, the institution, language—the entire system involved in showing the works—continues to be obsessed with the arrival point: the work of art. So today there is a kind of reverse ontological inquiry that is proposed to us, not so as to return to another fixed point (the ordinary object), but to see what happens when that reverse trajectory is undertaken, from B to A, and discover what is in between the polarities. It's also a way to open potential fields.

CK The question of ontology in the domain of art has been approached in different ways. The most common tries to provide a response to the question *what is art?* But that shifted, notably with Nelson Goodman, who deemed that it was phrased incorrectly and preferred the question *when is art?* which stresses aesthetic workings. I'm under the impression that with the example of magic, another shift could again take place, and the question would be *where is art?* So that would become a matter of placement, of movement and mobility

we look at a work of art, there are studies by neurologists and psychologists who have worked in collaboration with illusionists to analyze the way our brain functions when we watch a magic trick—in other words, when we are deceived. Magic is certainly one of the rare activities in which we ask to be deceived. Those studies on deception and lying allow us to understand the phenomena of belief that accompany them. Those analyses, in turn, can tell us about what happens with a work of art.

CK For you, are those scientific preoccupations still part of your line of inquiry, one focused on the limits of the visible and the limits of perception? And moreover, do you accept the term *inquiry* to describe your work as a curator?

MOW I can accept the term *inquiry* so long as there's a mystery for me to resolve, a mystery that remains whole because no specialist in ontology has resolved it: in other words, how does the transfiguration function, how does the ordinary object transform into a work of art? The approaches—whether semiological, logical, institutional, or other—cannot completely resolve the

problem, and the inquiry therefore has not ended. I feel that magic can help us partially resolve the question because it points toward what is happening in the area of belief.

CK Could we therefore describe your work as ontological inquiry? And if so, what role has the thinking of Arthur Danto played? He seems to be an important theoretical reference for you.

MOW I discovered Danto's books in the 1980s, and that was a kind of starting point for this inquiry for me. He asks the following question: six totally identical and visually indiscernible monochromes, having six different titles and made by six different artists, each with his own history—do they constitute a single work or six different works? My first project as a curator consisted in remaking those monochromes, inventing those six artists, and testing out if, indeed, we were dealing with six works or a single one. So I have always been interested in that transfiguration from one point to another, but it has taken on a new spin these past years, especially with the experiments conducted by the Chalet

MOW I never really thought about that, but it's interesting. That history of "modern magic," as you call it, began when illusionists and conjurers performed in front of an audience, in dedicated theaters, with ad-hoc machinery, which also corresponded to the advent of the modern museum and its opening to visitors—an expanded audience that included more than just art aficionados. Those movements certainly contributed to the revival of display and viewing. In modern illusionism, the magician doesn't grant himself transcendental, supernatural, or superhuman powers—on the contrary, it's an affirmation of the effect and the trick. The spectator is caught between two poles: on one hand, magic (total wonder), on the other, technique (the trick), which makes the stunt possible. The magician simultaneously asserts that there is a trick and that something impossible has happened. And the spectator is caught in that tension that can't really be resolved. He's aware that he's a prisoner of a trick, but also a prisoner of his belief in the fact that nothing before him has surpassed his understanding. There's an ambivalent belief between the credulity that leads to wonder and the incredulity that leads to discovering the trick. But those two polarities don't cancel each other out—on the contrary, they add to one another. What interests me about the magic trick is also what interests me about the work of art: that oscillation between two poles. (The work of art, between ordinary object and its transfiguration.) Duchamp, with the ready-made, like a magician, summoned that phenomenon of ambivalent belief and that logic of addition. It should also be noted that this polarity and ambivalence create oscillation: nothing solidifies around one of the poles at the detriment of the other.

CK That irresolute tension, that situation of instability, pulls us away from a formal understanding of the work of art.

MOW And there is something frustrating in the fact that it doesn't really solidify, except for in discourses generated to that end. A work of art is a bit like an answer you have on the tip of your tongue but that you continually have to search for. What's more, finding an answer would be of little interest. To a certain extent, I think that the work of art mimics how our brain functions. In that regard, while there aren't yet scientific studies that look at how our brain functions when

MOW It was one of the first pieces I thought of when I started working on the exhibition, and it's a rather fine example of the spirit [of the exhibition]. It starts with an ordinary subject, a bar of soap. (In the exhibition there are many "ordinary objects": a window, mirrors, bricks, shoes, air ducts, switches, hands, lightening, rock, a table, elephants, alligators, etc.) When you arrive in front of that work, the first thing you identify is a bar of soap. You have to be a bit curious and read its label, which tells us the following: One day the artist received a phone call from a nurse friend who worked in a private clinic in Ticino [Switzerland]. She tells him that Silvio Berlusconi has an appointment there for liposuction. Gianni Motti wanted to know what they were going to do with the removed fat. "Throw it out," she answered. So he asked that it be kept so he could use it. It's that fat that would be transformed into soap. The title of the work gives it all its complexity: *Mani Pulite* ("clean hands," in Italian) is in fact the name that was given to the big operation that was coordinated against the mafia in Italy at a time when Berlusconi was still suspected of maintaining special relationships with it, perhaps even as a member. That work caused a scandal when it was exhibited in Basel. The press latched on. In Italy, Berlusconi's lawyers denied its authenticity; the artist persisted, so one of them requested a DNA test. The artist agreed, which cut short the debate.

With that Gianni Motti piece, you can perfectly see the fearsome effectiveness of a side step, its critical strength also being relevant to the media's power.

CK The concept of that exhibition—even if no longer apparent in its execution—is based on a parallel between contemporary art and magic. And to that end, you consider the spectacles of magic, not the kind of ritual magic that has been practiced in human societies for a very long time. That nonritual magic could be described as "modern" since it defined its terms and its premises in the nineteenth century, at the very moment when art renewed its practices and exhibition with the Romantic revolution and the emergence of institutions. Based on the work you carried out for the exhibition, does it seem reasonable to you to establish such a parallel between art history and the history of magic?

ground in which you could admire your shoes (Adam McEwen), and a pressurized nitrogen-powered device that shot out glass bottles (Arcangelo Sassolino) . . . an entire universe that revolved around that nucleus.

> CK My second choice focused on Melvin Moti and his film *No Show* (2004) because he seems to offer us an entirely different way of understanding the disappearance/reappearance relationship, notably through recollection and reconstruction.

MOW You have to remember the story, the true story that's at the root of that work. It dates back to the Wehrmacht advance on Saint Petersburg during the Second World War, at which point steps were taken to protect cultural property. At the Hermitage Museum, tens of thousands of works had to be unframed and stored in safe places; it was a huge task that was accomplished with help from the Red Army. Once the operation was completed, the museum's curator decided to bring together all the soldiers and lead them on a guided tour of the museum's collection, even though there were only frames on the walls without paintings. Melvin Moti, drawing on personal accounts, was able to restore the curator's voice and reconstruct his museum tour in a video that runs twenty-four minutes.

The way the artist formalized the tour is interesting. The film begins with a static shot of a wall lighted from the side: it evokes religious subjects, their light, the joy of angels—and the remarks regarding the beauty of certain female saints get a big laugh from the soldiers. As the tour continues, the video darkens because the light diminishes, and the subjects darken, as well, until we arrive at Rembrandt's paintings. After night and darkness, the film ends with the evocation of things that are imperceptible against an entirely blackened background.

> CK The third work I suggest we look at is the piece by Gianni Motti, *Mani Pulite* (2005), which again proposes an entirely different understanding of that appearance/disappearance relationship. The artist's trick uses a figure that symbolizes political power and the power of money from the beginning of the twenty-first century, namely [former Italian Prime Minister] Silvio Berlusconi.

125

as a way of concretely approaching how they put these issues into perspective, each one differently. The first is Piero Manzoni's *Base magica* from 1961, a pedestal on which two feet (right and left) are outlined, implicitly inciting the viewer to stand there. . . . Here we have the case of a work whose title and principle imply the object's magical function.

MOW　　It's the only work in the exhibition that refers directly—through its title—to magic. The forty-five other pieces are rather far from the world of magic, intentionally so. When the artist presented that pedestal in the early 1960s, the viewer was asked to transform himself into a sculpture. (Today, you're not allowed to stand on it.) Here, the transfiguration happens in a direct manner.

　　CK　　And the viewer becomes an actor in that transfiguration: a physical actor who changes his or her point of view.

MOW　　It's interesting to understand that act as an echo of Marcel Duchamp's phrase, "It's the viewer who makes the painting," but you also have to stress that an active shift is part of it. The physical movement of the viewer who mounts the base manifests a specific property of the exhibition as medium: it has to be traversed. You have to keep in mind that each viewer constructs his own visit to the exhibition, his own choreography in space and time, and that each one is unique. Manzoni's "Magic Base" therefore pursues Duchamp's phrase but adds the physical position of the viewer's body to it. And even though you can't stand on it anymore, you can still have that experience mentally and understand the sense of that active shift.

　　CK　　Where was that piece placed in the exhibition?

MOW　　In the middle of a gallery where it functioned as a transitive object. You had to go around the pedestal and wonder what was happening on all sides. There was an electromagnetic energy transmitter (Robert Barry), an electric bug zapper (Fernando Ortega), a double door (Oscar Tuazon), a letter by René Magritte on magic, hands and a chair by Urs Fischer, a long mirror on the

Turn, when you make the thing presented disappear; and the third, the Prestige—which is the source of the magician's fame—when the disappeared element reappears. That three-part structure underlines the importance of the reappearance and the shift it supposes, and it entails a narrative arc common to very many stories, from the Bible to Batman. . . . The question then becomes, Can that narrative arc—drawn on in literature, the movies, and illusionism alike—be applied to art? And if so, in what manner? And that overlapped with one of my most constant concerns: understanding why an ordinary object transforms into another that we call a work of art. To me, that narrative arc offers us an explanation: we see an ordinary object (or referent) disappear before our eyes as an ordinary object and reappear as a work of art. From there, what interests me is deconstructing that process of transfiguration, underlining which elements it brings into play—the tensions and narrative arcs—so as to explain and understand what is happening in contemporary art.

CK The structure therefore functions as an impetus and model for an exhibition?

MOW Yes, it's an impetus, and the exhibition title, *The Transported Man*, echoes it, because it refers to Christopher Priest's book and the competition between two magicians that culminates in a trick in which one of them disappears from one spot on stage and reappears at another simultaneously. That simultaneity between disappearance and reappearance, that $t0$, is essential to the trick working—and the larger the distance between the place of disappearance and the place of appearance, the better the trick works. You find that $t0$ in art, but unlike magic, in art, the space is also "zero": the ordinary object doesn't move, it doesn't change, but the transformation still takes place, it's a work of art. So what are the clues that allow us to understand that phenomenon? That thought led me to wonder about belief, which is also at the heart of magic in its relationship to wonder, and which seems to me to be as important in art. You have to believe that what you see, the ordinary object, can be transformed into something else. And it's starting from that belief that different interpretations can develop.

CK I'd like to suggest three works included in this exhibition

CHRISTOPHE KIHM We did an interview in 2012 when you were presenting your final exhibition at the Palais de Tokyo before your departure, and you said this to me: "The program we were able to do at the Palais de Tokyo will continue in a different way, in a different place, under different conditions. In the end, chapter by chapter, I built a story about presentation, transformation, and disappearance and got to the point that a reappearance will happen elsewhere." Can we consider that "elsewhere" to be the MSU Broad and this exhibition to be the site of that reappearance?

MARC-OLIVIER WAHLER I've always been concerned with understanding how one exhibition might follow another, hence the importance of the notion of a program. The program that I pursued at the Palais de Tokyo—that story of presentation, transformation, and disappearance—was built around the end of "window vision." But building a program within an institution, as was the case at the Palais de Tokyo, is one thing. It's another to continue it differently, in another context, with other constraints. Every magic trick establishes as a principle that when a person disappears, he or she must appear elsewhere. Obviously, reappearance couldn't happen at the Palais de Tokyo, so when I took over as head of a new institution, it was rather clear that my first exhibition would be devoted to that reappearance.

CK Could you talk more about the title chosen for this exhibition, as well as the structure?

MOW The title directly refers to the research on visibility I conducted, notably with the Palais de Tokyo program. What happens when you touch on the limits of the visible, even if it's through the hyperspectacular, beyond the visible—in other words, when you become invisible? What happens later, when you go beyond the electromagnetic spectrum, when you not only become invisible but you disappear? After going down the path that leads to disappearance, I asked myself, Where do we go when we've disappeared? At the time, I was reading a book by Christopher Priest, *The Prestige*, in which the author explains that all magic tricks have three stages: the Pledge, or the presentation of something visible; the

Art, Belief, and Ambivalence

Marc-Olivier Wahler talks with Christophe Kihm

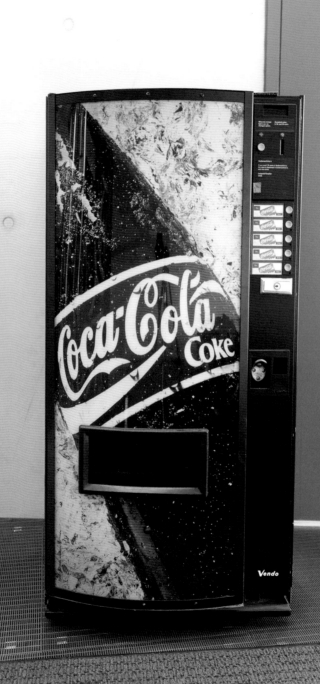

Leopold Kessler
Sodamachine a and b, 2006

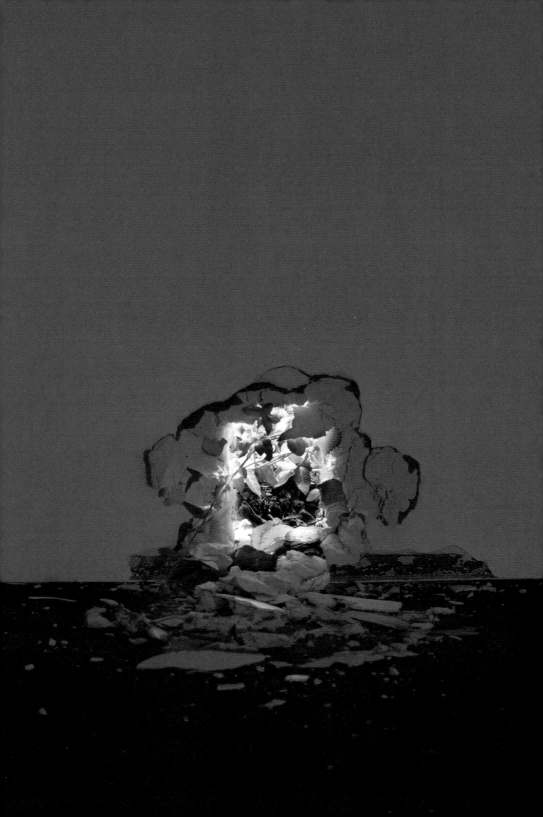

Ryan Gander
Nathaniel Knows, 2003

Fernando Ortega
Untitled (Fly Electrocutor), 2003

Robert Barry
Electromagnetic Energy Field, 1968

le 27 Juin 1946

Cher ami,

En Post Scriptum à ma dernière lettre :

J'ai repensé à vos propos sur la Magie, vous en respectez « les formes fixes » éprouvées par une longue expérience -

Je serais avec vous pour les défendre pour autant que cette magie traditionnelle puisse s'opposer avec violence à l'attitude et aux croyances des gens « raisonnables „ J'aime de cette façon aussi le signe de révolte que Représente la mise en avant du "principe féminin".

Il me serait facile, à présent, d'aimer une telle activité, car elle ressemble à la mienne qui me fait passer outre du soucis d'avoir toutes les chances d'efficacité - Actuellement, je vois notre plaisir comme but, alors qu'avant il n'était question que de bouleverser l'extérieur -

Je comprends l'Utopie ainsi : ce n'est pas un rêve qui doit se réaliser dans des temps futurs, L'Utopie serait de situer du âge d'or dans les limites de notre propre vie.

A part l'usage révoltant de la Magie, je dois dire que personnellement elle ne m'est d'aucune utilité (sinon la Magie poétique) elle me semble bonne à être oubliée avec les vieilles coutumes, les vieilles traditions, les vieilles religions et toutes les pauvretés de l'esprit se nourrissant de symboles. Vous ne redoutez pas plus je pense, l'envoûtement (qu'une excommunication du pape ?
(d'un sorcier)

A bientôt j'espère et bien amicalement à vous,

Magritte

René Magritte

Letter to André Breton, 1947

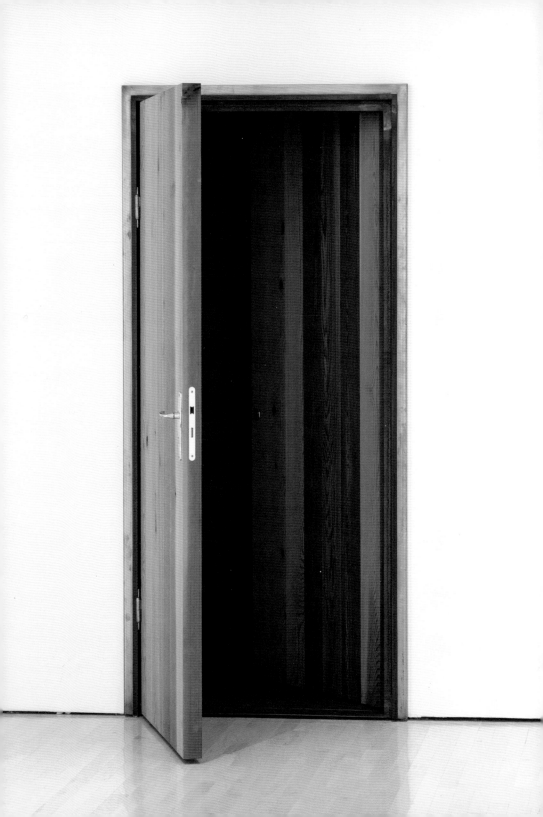

The Transported Man

Christopher Priest

Magic is metaphor. That was the thought I had, the inspiration, while I was writing the novel of *The Prestige*.

But magic is many more things. It is entertainment—most magic shows are full of laughter and surprise. The performance of magic is a life's commitment, like art, like literature, like a belief system—old magicians never die, they simply hide behind a half-silvered mirror.

Like sport, magic requires training and daily practice and a fit body. Magic is prepared in advance, like great cooking. Magic requires skill—badly performed magic is bad magic. Good magic is beautiful, though, like a masterpiece painting. A magician has to move with precision, perfect timing, be graceful, as if dancing. Like a lawyer in court, who while examining a witness never asks a question without knowing the answer in advance, a magician leaves nothing to chance. Magic can be an arresting, inexplicable puzzle, like a train emerging from a fireplace, or a clock that has melted. Or its absurdity will make you laugh.

Above all, magic tells a story—it has a beginning, a middle, and an end.

The one thing that magic is NOT, is magic. It is not sorcery, witchcraft, dark powers, the supernatural. Magic is a craft, it can be learned and perfected, but it is a craft which makes it appear that sorcery is involved.

To return to my interest in magic as a metaphor, the original instinct for *The Prestige* came from the observation that both literature and illusionism are narrative arts. They tell a story.

The magician will usually start with something ordinary or familiar—a deck of cards, a cell phone, a candle. What then follows is a divergence from normal: someone will be asked to write their name on one of the cards, then tear it up; the battery might be removed

from the cell phone, the candle placed underwater.

In literary terms, these are the first two narrative stages. The trick has already started.

In the film of *The Prestige*, the familiar object is given the label of "the Pledge." A pledge is something you know and recognize and understand, something that looks or feels true. It makes the audience confident of a baseline, a certainty.

The Pledge is the candle, the mobile phone, the deck of cards.

But then the magician does something unexpected, something odd or arresting. This can be called "the Turn." It draws attention to the fact that we are no longer in familiar territory. Why has the candle suddenly been put in water? What good is a mobile phone without a battery? Why has one of the playing cards been torn up?

Our interest is piqued.

Finally, the magician performs what seems to be a miracle: the torn-up playing card is restored, the battery-free mobile phone vibrates and rings, the candle burns underwater.

This third stage is called "the Prestige."

It would be wrong to aggrandize magic by claiming for it the highest aspirations of art. Even the most successful, or egotistical or arrogant magician will only ever admit to a wish to entertain, to surprise or amuse.

And of course, not all art is designed to cause surprise, let alone laughter. But art provokes a human response. Unlike a response to magic, it is usually quiet or silent appreciation. A crowded gallery is full of silence, but the viewers' senses are at work: the eyes, the mind, the emotions, the soul. Human response is often outwardly undetectable. Great art works by stealth: it creates an experience, a memory, a confirmation of

life's purpose. It enters the soul and will reside there for months, years, decades. It becomes the viewer's hidden agenda, the true influence on deeper motives, the explanation of mysteries, the connection made between day-to-day experience and the higher concepts of the mind.

Art cannot be forgotten.

Somewhere in there is the essence of magic. I have just returned from a convention of magicians. I saw a man and woman appear to exchange their clothes in a blink of an eye, I saw three short pieces of rope magically join up to become one continuous long one, I saw a man in chains and handcuffs immersed upside-down in a tank of water and somehow escape unscathed within two terrifying minutes. Not great art, but like art, it was mysterious and expert and moving—and unforgettable.

The Effects

Ellen
LeBlond-Schrader

This is a partial list of seven principal uses of magic that we humbly resume and present as a guide to *The Transported Man*. They are the unlikely, even unbelievable demonstrations of simple acts that temporarily shift our perspectives. Here, I use them to carve a path through the exhibition and as a springboard to speak elementarily about certain aspects of a few artworks. Far from an expert, we are more a neighborly guide.

We'll borrow terminology from Christopher Priest's book *The Prestige* (1995), in which he describes magic tricks as containing three parts: the Pledge, the Turn, and the Prestige. The Pledge is the presentation of an object and what will happen. The Turn is the action (a disappearance, for example). The Prestige is the restoration of the object to its previous state during the Pledge, unaltered by the effects of the Turn. Although not all of these magical terms discussed below fit into this schema, these terms can be helpful in explaining the tricks and their use of space and time.

LEVITATION

Levitation is the use of magic to give the appearance of temporarily suspending the law of gravity. During levitation, a body or object hovers or floats in midair above ground or water without the apparent aid of physical or material forms of suspension.

The Masked Magician (aka Val Valentino) performs a levitation trick by raising a woman (who is lying down) into the air in a horizontal levitation. This trick uses a support that is unseen by the audience. In this example, he performs the trick by balancing her on a metal support that is dressed to mimic one of the magician's legs. A similar popular technique is the use of highly polished metal columns, which reflect the colors and textures of the background, in combination with special lighting.

Although the visual results of different forms of levitation are similar, the manner in which they are accomplished varies. In some cases, a support is visible, although this form of suspension is ultimately misleading: a body may appear to be balanced on his fingertips, or on a precarious or lightweight object, such as a sword or stick. In these cases, the supports are specially reinforced to suspend the body, and usually a harness is attached to the body. Also,

a combination of hooks and counterweights can be used to hoist the body or object into the air. Yet a third variation is the balancing of one foot on a subtle rise in the floor, which is hidden by the second foot.

In *The Transported Man*, Roman Signer's table (*Table*, 2009) levitates above the floor. In reality, a fan discreetly installed below the surface of the floor forcefully blows an airstream out a hole up under the table, lifting the table into the air and balancing it in midair. Unlike with the magic trick, here the spectator sees the hole in the floor, but the support (the airstream) is invisible. The invisibility of the airstream creates the illusion of a levitating table.

The Illusion of Trilby as performed
by Professor Hermann as Svengali

The Ethereal Suspension, first performed
by Robert-Houdin on October 10, 1849

Gianni Motti
Levitation, 1995

PRODUCTION
AND RESTORATION

Production (the initial and sudden appearance of someone or something) and restoration (the reappearance of the original status or form of someone or something) appear as two different acts to the audience. However, for the magician, these two illusions can overlap.

Production can be thought of as presentation. It can be slow or fast, but it must appear unreasonable and without easy physical explanation. In Christopher Priest's example, production is the first element of the trick: the Pledge. The Prestige, or third element of the trick, is the restoration of the object to its state in the Pledge, unaltered by the effects of the Turn. For this reason, we propose that we deal with them together.

First, we must return to production. A famous example is the magician pulling a rabbit out of his hat. In this trick, the magician first appears onstage wearing a top hat. He takes off the hat, turns it over, and sometimes shakes it to reveal that nothing is hidden inside. Then he pulls a live rabbit out of this hat. This is considered production because it is the appearance of something that is impossible: the rabbit is too big and squirms too much to sit unseen inside the magician's top hat, particularly when the hat is still on his head.

Restoration is the return to the original condition or form of a destroyed or disappeared object, and is sometimes thought of as reappearance. The object may or may not bear the trace of this previous change in condition. Here, we have included the sometimes-separate notion of modification, since a temporary modification is implicit in any act of restoration.

The generic trick "Woman Sawed in Half" is a popular example of restoration. Here, a woman enters into a long box with her smiling head sticking out of one side and her wiggling feet on the other. The box is then sawed in half. In reality, there are two women in two boxes. The two halves are from different women. The recently sawed-in-half boxes are often rolled around the stage independently of each other. Then, the magician reestablishes the box as one piece and *restores* the woman to her whole. She, the woman that the audience saw enter the box, then jumps out unscathed. Although this is a generic and common trick with many variations, Horace Goldin first performed the common version described here, in 1921.

In *The Transported Man*, several pieces demonstrate these notions of production and reproduction. In Jonathan Monk's *Second Hand Daily Exchange* (2006), two wax hands under a glass box can be seen as an example

of production. The wax hands have an object displayed in them. The object is selected by the museum workers and changed daily. This sudden appearance of different objects each day under the security of the glass case (where usually neither spectators nor museum staff interfere) mimics the incredulity of the rabbit being pulled out of a hat. Furthermore, the objects' appearance on these lifelike hands, which look as if they've been amputated from a wax body, recalls the surprise inherent in production.

Tony Matelli's *Weed (#370)* (2016) plays off this notion of restoration. The *Weeds* are bronze reproductions of common weeds, painted to look like real-life plants. These particular weeds are commonly seen growing in the cracks next to buildings or in between sidewalks in any town or city. The bronze statues in the shape of weeds appear both outside the museum and inside the exhibition. They appear as if they're growing from the cracks in the floors or walls of the museum.

Restoration is usually completed in one of two ways: First, by substituting the original object with an identical or nearly identical copy. For instance, a watermelon is crushed, then a magician throws a magical cover over it, and the watermelon appears whole again as if never smashed. In this trick, the watermelon is replaced with a second, nearly identical watermelon. This substitution can also take place before some form of destruction, or vanishing. It may be the copy that suffers destruction and not the original. Here, we see a clear overlap with production.

Alternatively, the object may never have been damaged or changed in shape in any way. There may only be the appearance or implication of change. A simple example might be the previously recorded sound of glass breaking accompanied by bright light to make it appear as if a glass had broken. The sound and light create an illusion of destruction. In fact, the glass itself was never touched.

Robert-Houdin's Incredible Box

The Marvelous Orange Tree by Robert-Houdin

The Invisible Woman of Capuchin Convent, Paris

The Endless Paper Ribbon Hat Trick

Ryan Gander
Your Righteousness!, 2016

VANISHING

The act of vanishing is the use of magic to cause the disappearance of an object, thing, or person. Vanishing is the Turn, or second step of the magic trick, according to Christopher Priest. In its most basic form, vanishing is the reversal of the Pledge, which would be production in this trick. Similar to production, vanishing may be slow or fast, but it must appear unlikely.

Harry Houdini performed the largest vanishing act, "The Vanishing Elephant," at the New York Hippodrome on January 7, 1918. The trick was initially devised by Charles Morritt, who was famous for "The Disappearing Donkey" in Britain, and the worldwide performance rights were purchased by Houdini. The trick involves Jennie, a 10,000-pound elephant, who walks up a ramp onto the stage and into a very large box surrounded with curtains. Houdini works his magic, marked by the firing of a pistol, and his assistants open the curtains to reveal that Jennie has disappeared.

In *The Transported Man*, we witness the disappearance, or vanishing, of the museum director, Marc-Olivier Wahler, into the belly of the crocodile in Christian Jankowski's work *What Could Possibly Go Wrong?* (2017). Jankowski uses camera angles and perspective to make it appear as if the crocodile has eaten the museum director. A cameraman and a journalist then record an interview with Wahler through the walls of the crocodile's stomach.

PENETRATION
AND VENTRILOQUISM

Penetration can be the partial or complete piercing of an object or person without any visible alterations, either temporary or permanent. In other words, the object or person remains completely unchanged by the penetration.

As we've discussed in many of the previous illusions, each trick can have three parts: 1. Present the object, 2. Do the magic, 3. Reconstitute the object. This trick is somewhat different than those previously discussed because the second and third steps are indistinguishable and immediate. The subject is presented, and after the subject is penetrated, it remains unaltered even for the smallest amount of time.

An example is the Mr. Magic kit Block Go, in which a solid block falls down a chimney and penetrates a glass plate without damaging the glass. This particular trick is performed with two blocks, but other penetration tricks may rely on secret passages or a secret deviation in the path of the penetrating object. In other words, the object may simply go around the obstacle.

Ventriloquism is the projection of the magician's voice to animate an inanimate object. The magician speaks without moving his or her lips. Simultaneously, the magician physically manipulates an object, commonly a wooden doll or "dummy," as if the inanimate doll were speaking. A famous and ongoing example of this trick has been performed regularly since 1980 by David Strassman with the aid of his wooden dummy, Chuck Wood. We can also interpret ventriloquism as a vocal or audio penetration of an object.

In *The Transported Man*, Marcel Duchamp's *Miroir* (Mirror) (1964) reflects the images of the museum, its artworks, and its visitors, and features a reversed engraving of Duchamp's signature. Images are reflected back to the spectator, effectively signed by the artist via the reflection. The spectator can interpret the reflection as a ready-made work seen through the mirror, which can in turn be seen as a window into another plane. Duchamp completed this work shortly before his death, but the signed mirror serves as a way for the artist to continue making ready-mades from beyond the grave. Through the use of his reversed signature, Duchamp effectively penetrates our world from the world beyond.

In addition, Duchamp's signature not only penetrates our immediate present but is projected into our present, similar to the way spoken words are ventriloquized into a dummy. The mirror can be interpreted as a kind of mystical ventriloquism from the dead.

Sword Trick - A Stab Through the Abdomen

The Glove Column by Robert-Houdin

Robert Gober
Untitled, 1995–1997 (detail)

TRANSPOSITION
AND TRANSPORTATION

Transposition and *transportation* are two terms for the same trick: the unseen change in position of an object or person. A variation is a compound transposition, in which two objects change places. The trick can be performed out in the open or hidden from view—under a cloth or behind a screen, for example. Some small amount of time must take place, although the change in time must not be related to the time of displacement. The trick may be nearly instantaneous or gradual, but the spectator must have the illusion that the object has traveled. If the restoration or reappearance is instantaneous, then the spectator becomes aware of the multiplicity of objects. This trick is often performed with two identical or nearly identical objects or people.

An example of this trick is "The Transported Man," for which the exhibition is named: a man enters a door at one side of the stage, vanishes, and almost immediately appears behind a second door on the other side of the stage. The magician is invisible for a very short amount of time, which is not long enough to sprint to a second door under the stage or behind the curtain. It is essential that the magician vanishes completely, but only momentarily. In transposition, the object appears physically unchanged and identical. The magic is less in the collapse of space than the lapse in time. What is magical about this trick is not the physical displacement of the person but the nearly instantaneous transposition of the person in relation to the space traveled—the magician is one person, the same man standing next to one door and immediately walking out another. It is this conversion of one thing to another through space and time that is magical.

An example of transposition in the exhibition is George Méliès's film *Match de prestidigitation* (A Wager between Two Magicians) (1904). Here, Méliès splits the screen and uses a slight delay in time to create a competition between two identical magicians. In the film, one magician performs a trick, then the second magician tries to perform it. In reality, the two magicians are the same person, with the trick transposed in time and on a different side of the split screen. In the film, the magician and the trick are the "object" transposed.

As previously stated, the exhibition *The Transported Man* is named after the famous illusion. Director Marc-Olivier Wahler proposes that artworks function similarly to transportations. Although an artwork doesn't necessarily physically move through space, it can be seen as two separate

The Traveling Bottle and Glass

Trick Photography – Man in a Bottle

objects that transpose nearly simultaneously. It is the *nearly* that we must explore. In the three examples from Luca Francesconi's series *Abbassare le Montagne* (To Lower the Mountains) (2005) shown in *The Transported Man*, the artworks are rocks on pedestals. Within the short time needed to read and understand these rocks, they vanish, and in their places are the tops of three mountains: *Alpes de Gressoney, 1500m, Vallée d'Aoste; Monte Turchino, 682m, Ligurie;* and *Monte Kusna, 2121m, Emilie-Toscane*. In a short space of time, the spectator sees simple rocks, the rocks vanish and travel in the mind's eye to mountain summits, and the rocks reappear as the tops of mountains removed and installed on pedestals. The reappearance is "nearly instantaneous," but it does necessitate some time to understand and reposition the rocks in one's mind.

Another example is Gianni Motti's *Mani Pulite* (2005). Here, the spectator sees a bar of soap. This soap sports the name of former Italian Prime Minister Silvio Berlusconi's antimafia campaign and is made from the fat supposedly liposuctioned out of Berlusconi's tummy. Again, the soap disappears and travels from the museum into a luxury health clinic, through snorting vacuum tubes, and back into the gut of the Italian politician, and it almost instantly

reappears as a commentary of aetheticization of Italian politics.

These artworks are not physically transported through space, but they do travel in the mind's eye. An artwork appears at once as a rock and a mountaintop, as a bar of soap and political commentary. Of course, in the magic trick, the object or person doesn't physically travel through space either, since the trick involves two separate but identical subjects—we just believe it does.

The Clock Tower Leicester England May 7th 2024 Noon

Jonathan Monk
Meeting #100, 2012

TRANSFORMATION

In transformation, an object or person is visibly altered or changed either out in the open or behind a cover. This change must leave a visible mark, particularly if the transformation takes place behind a cover. Usually one object is substituted for another. For instance, in a magic trick, a dove may be transformed into a bouquet of flowers with a tap of a wand.

In *The Transported Man*, Daniel Firman's *Loxodonta* (2017) transforms an elephant into an aerial performer. The elephant not only breaks all laws of gravity but is transformed into an object that is lighter than air, e.g., a balloon or a bird.

On a certain level, the transposition of an artwork could be seen in terms of the magic trick transformation. Indeed, transposition and transformation are related. However, a key difference between these two illusions is that in transposition, the object remains physically unchanged; transposition uses multiple objects, but it must appear as if there is one object for the illusion to be successful. In transformation, the object or person must appear transformed, changed, by the experience. In our example, Firman's elephant is transformed into an aerial performer or a flying animal.

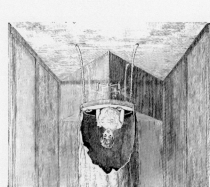

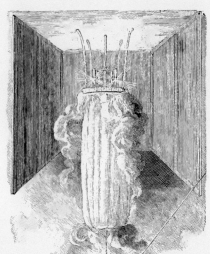

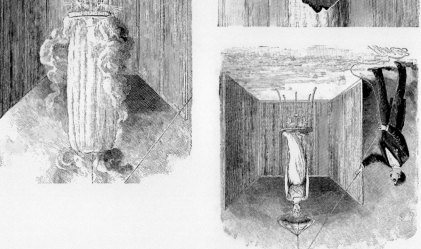

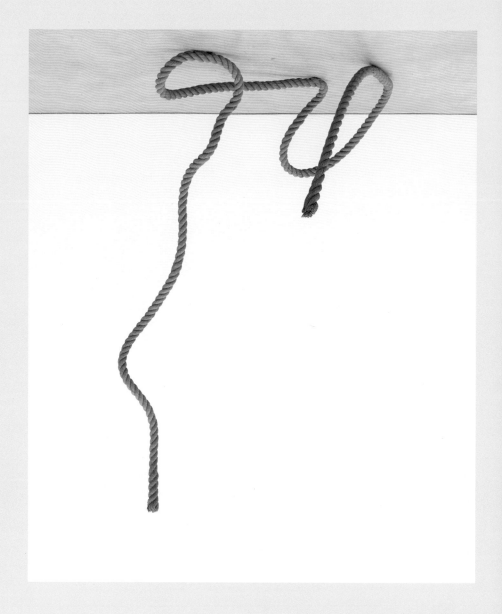

EXPLOSION AND ESCAPE

Perhaps explosion and escape require the least amount of explanation. Explosion is often the disappearance or appearance of something or someone in a cloud of smoke, frequently using a small amount of gunpowder. The object or person might be destroyed or might simply vanish. Escape is the magician's ability to unshackle or free him- or herself. Though these two effects use very different skills, the end result is a sudden freedom and shift in relationship with the outside environment.

No discussion of escapism would be complete without mentioning Harry Houdini's "Chinese Water Torture Cell." Houdini's assistants would lock his feet in stocks. Then they would cover his body in a steel frame that was also secured to the stocks. Houdini was then hoisted into the air and dropped headfirst into the tank. The stocks were fixed to the top of the tank and a cover placed over the tank for two minutes. Behind the cover, Houdini would use a key, levers, and hand bars to twist his head above the water level and escape.

In *The Transported Man*, Arcangelo Sassolino's *Piccole Guerre* (Little Wars) (2016) demonstrates explosion in a small tank. An empty, glass, Italian mineral-water bottle sits inside the tank. At a random point during the day, the pressure slowly begins to build inside the tank—it builds until finally the bottle explodes. The glass is contained, but the sound of the explosion echoes throughout the museum.

Another example that features a small explosion, combined with a mini escape, is Fernando Ortega's bug zapper, *Untitled (Fly Electrocutor)* (2003). The bug, which has "escaped" into the museum from outside—or more likely still, from Robin Meier and André Gwerder's neighboring work, *Synchronicity (East Lansing)* (2017)—flies into the bug zapper. The zapper zaps, killing the bug, but instead of lighting up, it causes all the lights in the gallery to suddenly go momentarily dark. (The bug zapper is connected to the museum's power supply.) Here, not only does the bug explode but spectators have the illusion that a fuse in the museum has shorted out. In addition, the bug has arguably escaped either the outside world or the tented artwork, but the spectator also temporarily escapes the exhibition in the pitch-black exhibition space.

Harry Houdini in 1899

The Chinese Water Torture Cell, first performed by Harry
Houdini at at the Circus Busch in Berlin, on September 21, 1912

Abigail Lane
You Know Who You Are, 2000

Appendix

Dave Allen (b. 1963)
For the Dogs. Satie's "Véritables Préludes Flasques (pour un chien)," 1912, rendered at tone frequencies above 18kHz, 2002
DAT player, amplifier, modified speakers, recording
Courtesy of the artist and Elastic Gallery, Stockholm

A piano composition by the French musician Erik Satie at a frequency above 18kHz—inaudible to humans but audible to dogs.

William Anastasi (b. 1933)
What was real in the world, 1964
Concrete sand bricks
16 x 29¼ x 15¼ in. (40.6.4 x 38.8 cm)
Courtesy of the artist and Galerie Jocelyn Wolff, Paris

Keith Arnatt (1930–2008)
Self Burial in nine stages, June '69, for Gustav Adolf and Stella Baum
Maquette, 9 black-and-white photographs on board
11 x 83 in. (27.9 x 210.8 cm)
Collection Amy Gold and Brett Gorvy, New York

Robert Barry (b. 1936)
Electromagnetic Energy Field, 1968
Electromagnetic energy transmitter, aluminum box
Overall: 3 x 4 x 2¼ in. (7.6 x 10.3 x 5.8 cm)
Collection Walker Art Center, Minneapolis, T. B. Walker Acquisition Fund, 2008

Invisible to the human eye, electromagnetism surrounds us at all times and gives shape to all objects.

Jason Dodge (b. 1969)
Courtesy of the artist and Casey Kaplan, New York

Marcel Duchamp (1887–1968)
Miroir (Mirror), 1964
Mirror and wooden frame
13¾ x 9⅝ in. (35 x 24.5 cm)
Anonymous loan

Near the end of his life, Duchamp framed and signed (in reverse) a common reflective surface, forever transforming reflected images into unique, evolving, participatory artworks—even after the artist's death.

Daniel Firman (b. 1966)
Loxodonta, 2017
Flexible polyurethane, polyester resin, steel, fiberglass
259⅞ x 110¼ x 63 in. (660 x 280 x 160 cm)
Courtesy of the artist

Urs Fischer (b. 1973)
Untitled, 2015
Found wooden chair, string, screws, silicone, pigments, silicone adhesive
41¼ x 22¼ x 28 in. (104.9 x 56.5 x 71.1 cm)
Private collection, courtesy of the artist

Hands, 2002
Aluminum, spray paint, car polish
28¾ x 11¾ in. (73 x 30 cm)
Courtesy of the Ringier Collection, Switzerland

Imaginary Pain, 2007
Cast plaster of Paris, screw, enamel paint
23⅝ x 23⅝ x 7⅞ in. (60 x 60 x 20 cm)
Private collection

Ceal Floyer (b. 1968)
Light Switch, 1992–99
35mm slide, slide mask, slide projector with 70-120mm lens
Courtesy of Shan Qiang

Luca Francesconi (b. 1979)
Alpes de Gressoney, 1500m, Vallée d'Aoste
From the series *Abbassare le Montagne*
(To Lower the Mountains), 2005
Stone
1⅛ x 4⅛ x 2½ in. (5 x 11.3 x 6.5 cm)
Courtesy of Valais Art Museum, Sion,
Switzerland

Monte Turchino, 682m, Ligurie
From the series *Abbassare le Montagne*
(To Lower the Mountains), 2005
Stone
2¾ x 10¾ x 6¾ in. (7 x 27.5 x 17 cm)
Courtesy of Valais Art Museum, Sion,
Switzerland

Monte Kusna, 2121m, Emilie-Toscane
From the series *Abbassare le Montagne*
(To Lower the Mountains), 2005
Stone
9 1/2 x 13 1/2 x 6 1/2 in. (24 cm x 34.5 x 17 cm)
Private collection, Michigan

During three separate hikes in Italy,
Francesconi removed the peaks of three
mountains, lowering the summits by
a few inches.

Ryan Gander (b. 1976)
Nathaniel Knows, 2003
False partitioning walls, breezeblock, metal
fixtures, black carpet, oak bark, light
Dimensions variable
Collection SATO Tatsumi

Robert Gober (b. 1954)
Drains, 1990
Cast pewter
4¼ x 3¼ in. (Diameter 11 cm, thickness 8 cm)
Collection Museum of Contemporary Art,
Los Angeles, Gift of Christopher Wool

Plywood, 1987
Laminated fir, medium-density fiberboard
84 x 31 x 11½ in. (213.4 x 78.8 x 29.3 cm)
Collection Andrew Ong and George
Robertson, New York

Sigurður Guðmundsson (b. 1942)
Rendez-vous, 1976
Gelatin silver print on fiber-based paper, text
12⅞ x 18⅞ in. (33 x 48 cm)
Courtesy of the artist and i8 Gallery,
Reykjavik

Study for Horizon, 1975
Chromogenic print, Letraset text on card
12⅞ x 18⅞ in. (33 x 48 cm)
Courtesy of the artist and i8 Gallery,
Reykjavik

Christian Jankowski (b. 1968)
What Could Possibly Go Wrong?, 2017
Performance and mixed-media installation
Courtesy of the artist

Leopold Kessler (b. 1976)
Sodamachine a and b, 2006
Two soda machines
56½ x 27½ x 29½ in. (143.5 x 69.9 x 74.9 cm)
Courtesy of Loevenbruck Collection,
Paris, France

When coins go into one machine, a can
of soda is "beamed" to the other machine.

Joachim Koester (b. 1962)
The Magic Mirror of John Dee, 2006
Gelatin silver print with text
10 x 13¼ in. (25.5 x 33.5 cm)
Private collection, Michigan

Alicja Kwade (b. 1979)
Linienland II, 2017
Found object, wood, iron, lapis lazuli
9 x 8½ x ⅜ in. (23 x 21.5 x 1 cm)
Courtesy of the artist and 303 Gallery,
New York

René Magritte (1898–1967)
Letter to André Breton, 1947
Ink on paper
10½ x 8 in. (26.8 x 20.3 cm)
Collection Blake Byrne, Los Angeles

Anna Maria Maiolino (b. 1942)
Ad Hoc, 1982
Super 8 mm film transferred to video, sound
3:42 min.
Courtesy of the artist and Hauser & Wirth,
Zurich

Piero Manzoni (1933–1963)
Base magica–Scultura vivente
(Magic Base–Living Sculpture), 1961
Wood, metal, felt
23⅔ x 31⅓ x 31⅓ in. (60 x 79.5 x 79.5 cm)
Courtesy of the Fondazione Piero Manzoni,
Milan

The artist asserts that anyone who stands
on the piece's felt cutouts becomes a living
work of art.

Tony Matelli (b. 1971)
Weed (#370), 2016
Painted bronze
14 x 8 x 7 in. (35.6 x 20.3 x 17.8 cm)
Courtesy of the artist and Marlborough
Contemporary Chelsea, New York

Weed (#384), 2017
Painted bronze
29½ x 14 x 11¼ in. (74.9 x 35.6 x 28.6 cm)
Courtesy of the artist and Marlborough
Contemporary Chelsea, New York

Weed (#337), 2014
Painted bronze
14½ x 20½ x 9 in. (36.8 x 52.1 x 22.9 cm)
Courtesy of the artist and Marlborough
Contemporary Chelsea, New York

Adam McEwen (b. 1965)
Shoegazer, 2002
Bronze mirror
Dimensions variable
Courtesy of the artist

Robin Meier and André Gwerder
(b. 1980; b. 1978)
Synchronicity (East Lansing), 2017
Mixed-media installation
Dimensions variable
Courtesy of the artists; produced by
Audemars Piguet Art Commission, 2015

Live fireflies and katydids flash and chirp
in unison with four communicating record
players. Not only do the insects respond to
the electronic signals but they adapt their
physiological systems, creating a symbiosis
between the living and the artificial.

Georges Méliès (1861–1938)
Match de prestidigitation
(A Wager between Two Magicians), 1904
Film transferred to video, black and white,
silent
1:31 min.
Courtesy of the National Film Archive, Prague

Jonathan Monk (b. 1969)
Second Hand Daily Exchange, 2006
Wax
Two parts, each: 8 x 4 x 4 in.
(20 x 10 x 10 cm)
Courtesy of the artist and Lisson Gallery,
London

Every day a new object (chosen by the museum staff) is placed in the palms of the artist's wax hands.

Melvin Moti (b. 1977)
No Show, 2004
16mm film transferred to video, color, sound
27 min.
Courtesy of the artist

Gianni Motti (b. 1958)
Mani Pulite, 2005
Soap, sodium hydroxide, Silvio Berlusconi's fat
3⅜ x 2 x ¾ in. (8.5 x 5 x 1.9 cm)
Private collection, courtesy of Galerie Bruno Bischofberger, Männedorf-Zurich, Switzerland

Fernando Ortega (b. 1971)
Untitled (Fly Electrocutor), 2003
Fly-killing device
50 x 23 x 6¼ in. (127 x 58.4 x 15.9 cm)
Courtesy of the artist and kurimanzutto, Mexico City

The device is synchronized with the power supply of the room, causing a momentary blackout each time a fly is electrocuted.

Robert Overby (1935–1993)
Two Window Wall Map, 1972
Canvas
105½ x 160 in. (268 x 406.4 cm)
Courtesy of the artist and Andrew Kreps Gallery, New York

Charlotte Posenenske (1930-1985)
Series D Vierkantrohre
(Series D Square Tubes), 1967–2007
Element, hot-dip galvanized steel sheet
Square tube: 18⅛ x 18⅛ x 36¼ in.
(46 x 46 x 92 cm); rectangular tube:
9 x 18⅛ x 36¼ in. (23 x 46 x 92 cm);
angular element, opening: 18⅛ x 18⅛ in.
(46 x 46 cm); transition element, opening:
18⅛ x 18⅛ in. (46 x 46 cm)
Courtesy of the Estate of Charlotte Posenenske; Mehdi Chouakri, Berlin; and Peter Freeman, New York

Series D Vierkantrohre
(Series D Square Tubes), 1967–2007
Element, hot-dip galvanized steel sheet
Square tube: 18⅛ x 18⅛ x 36¼ in.
(46 x 46 x 92 cm); rectangular tube:
9 x 18⅛ x 36¼ in. (23 x 46 x 92 cm);
angular element, opening: 18⅛ x 18⅛ in.
(46 x 46 cm); transition element, openings:
18⅛ x 18⅛ in. (46 x 46 cm)
Courtesy of the Estate of Charlotte Posenenske; Mehdi Chouakri, Berlin; and Peter Freeman, New York

These industrial air ducts, modular in design and originally installed in public spaces (airports, train stations, etc.), can be arranged in any number of different configurations.

Werner Reiterer (b. 1964)
Beginnings of Space Travel, 2002
Taxidermied cat, pipe, gas cylinder
Approx. 136¾ x 39⅜ x 39⅜
(350 x 100 x 100 cm)
Courtesy of Loevenbruck Collection, Paris

Hannah Rickards (b. 1979)
Thunder, 2005
Sound installation with text
Courtesy of the artist

Ugo Rondinone (b. 1964)
Clockwork for Oracles II, 2008
Mirror, colored plastic gel, wood, paint
Dimensions variable
Courtesy of the artist and Gladstone Gallery,
New York

Arcangelo Sassolino (b. 1967)
Piccole Guerre (Little Wars), 2016
Stainless steel, glass, nitrogen
Dimensions variable
Courtesy of the artist and Galleria Continua,
San Gimignano, Italy

Pressurized nitrogen gas is slowly injected
into a glass bottle until it explodes—in
a moment that arrives suddenly and
unpredictably.

Roman Signer (b. 1938)
Table, 2009
Balsa wood
28⅜ x 42⅛ x 26¾ in. (72 x 107 x 68 cm)
Courtesy of the artist and Galerie Art:
Concept, Paris

Paul Thek (b. 1933)
Untitled (L-Column), 1965–1966
Beeswax, Plexiglas, metal
30½ x 30½ x 9 in. (77.5 x 77.5 x 22.9 cm)
Museum Voorlinden, Wassenaar,
the Netherlands

Oscar Tuazon (b. 1975)
Rooms, 2012
Steel, cedar wood, steel lock
Two parts, each: 84¼ x 33⅞ x 5½ in.
(214 x 88.5 x 14 cm)
Courtesy of the artist

Unknown (late 14th century)
Seated Bishop
Walnut with traces of paint
53 x 20 in. (134.6 x 50.75 cm)
Eli and Edythe Broad Art Museum, Michigan
State University, Gift of Mrs. Gladys Olds
Anderson and Ransom Fidelity Co., 68.22

Wolf Vostell (1932–1998)
Betonbuch (Concrete Book), 1971
Book made in concrete with incised signature
on metal plate, and incised numbers
13½ x 10 x 2 in. (34 x 25 x 4.5 cm)
Special Collections Research Center,
University of Chicago Library

Ian Wilson (b. 1940)
*There were discussions in Dusseldorf
in 1970*, 1970
Typewritten certificate, signed by the artist
11 x 8½ in. (28 x 21.6 cm)
Courtesy of the artist and Jan Mot,
Brussels and Mexico City

*There was a discussion at the Galleria
Toselli in Milan, March 30, 1973*, 1973
Typewritten certificate, signed by the artist
10⅞ x 8½ in. (27.9 x 21.6 cm)
Courtesy of the artist and Jan Mot,
Brussels and Mexico City

*There was a discussion with Lucy Lippard in
New York City (11th Avenue) in 1969*, 1969
Typewritten certificate, signed by the artist
10⅞ x 8½ in. (27.9 x 21.6 cm)
Courtesy of the artist and Jan Mot,
Brussels and Mexico City

ACKNOWLEDGMENTS

I would like to start by thanking author Christopher Priest for providing the inspiration for *The Transported Man* exhibition, and for the essay he contributed to this publication. A warm thank-you to Christophe Kihm for his thoughtful interview questions, which have helped me to clarify my ideas about this project.

This exhibition wouldn't have been possible without the support and commitment of all the artists who contributed to it, many of whom came on-site to produce or install their works. To the numerous lenders, from private and public collections: thank you for your trust and support.

Special thanks to Maricris Herrera and her team of graphic designers at Estudio Herrera; copy editor Anne Ray; the translation services of Molly Stevens; and my lovely wife, Ellen Leblond-Schrader, for helping to formulate my ideas in both the galleries and the texts in the pages of this book.

I also would like to extend my thanks to Provost June Youatt and Eli and Edythe Broad, who trusted me and enabled me to implement this project. And a special thanks for their support and advice to Bill Ravlin, Gary L. Parsons, Winka Angelrath, Andras Szanto, Laurent Dumas, Tristan Garcia, Mark Alizart, and many more.

Finally, many thanks to the team at MSU Broad for seeing the exhibition and publication to completion: Carla Acevedo-Yates, Steven L. Bridges, Amy Brown, Jayne Goeddeke, Brian Kirschensteiner, Cory VanderZwaag, Rachel Vargas, and exhibition publication intern Tyler Forton. You all helped make the magic happen.

Photo credits: pg. 21 Robin Meier and André
Gwerder; pg. 23-29, 33, 35, 43, 45, 49, 51,
55, 57, 63-85, 95, 97, 105, 107, 111, 115-119,
163-165, 174-175, 178-179, 182-183, 186-189,
192-193 Eat Pomegranate Photography;
pg. 39 Sandra Pointet, courtesy the artist
and Casey Kaplan, New York; pg. 61 Galerie
Bruno Bischofberger, Männedorf-Zurich,
Switzerland; pg. 89, 152-157 National Film
Archive, Prague (film still); pg. 93, 168-173
Christian Jankowski; pg. 103 Ela Bialkowska,
courtesy the artist and GALLERIA CONTINUA,
San Gimignano / Beijing / Les Moulins /
Habana; pg. 113 Walker Art Center, Walker Art
Center, Minneapolis T. B. Walker Acquisition
Fund, 2008; pg.210 Marek Rogowiec;
pg. 213 Joshua White courtesy Emanuel
Hoffmann Foundation, on permanent loan
to the Öffentliche Kunstsammlung Basel
(permanently installed at Schaulager Basel).

All other images courtesy Aaron Word,
MSU Broad.

The Transported Man was set
in Belwe, Graphik, and Mercury
typeface.

Printer: InnerWorkings Inc.,
Grand Rapids, MI.
Printed in China.

ISBN: 978-1-941789-05-6
broadmuseum.msu.edu
MSU Broad books are available by
The Michigan State University Press
1405 South Harrison Road, Suite 25
East Lansing, MI 48823
msupress.org

The Transported Man
Edited by Marc-Olivier Wahler

Published on the occasion of the exhibition
The Transported Man (April 29, 2017–October
22, 2017), organized by the Eli and Edythe
Broad Art Museum at Michigan State
University and curated by Marc-Olivier Wahler.

Support for *The Transported Man* is
provided by the MSU Federal Credit Union,
the Swiss Arts Council Pro Helvetia,
Audemars Piguet, the Eli and Edythe Broad
Endowed Exhibition Fund, and the MSU
Broad's general exhibitions fund.
All rights reserved.

Editor
Marc-Olivier Wahler

Authors
Christophe Kihm
Ellen LeBlond-Schrader
Christopher Priest
Francis Ponge

Copy Editor
Anne Ray

Translator
Molly Stevens

Design
Maricris Herrera
Emilio Pérez
(Estudio Herrera, Mexico City)

Sources

Hopkins, Albert A. and Henry Ridgely Evans.
*Magic: Stage Illusions and Scientific
Diversions, Including Trick Photography*.
London: Low, 1897.

Robert-Houdin, Jean-Eugène. *Confidences
et révélations: Comment on devient sorcier*.
Paris: A Delahays, 1868.

Hoffman, Professor. *Modern Magic:
A Practical Treatise On The Art Of Conjuring*.
London and New York: George Routledge
and Sons, 1877.